BEAUTIFUL ORIGAMI FLOWERS

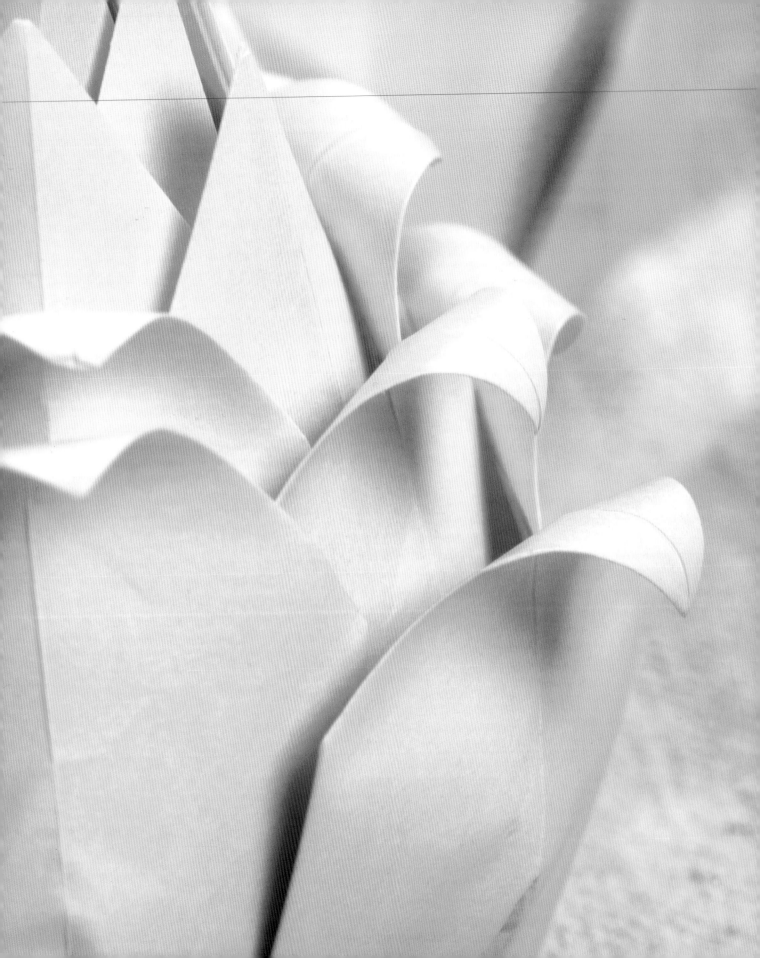

BEAUTIFUL ORIGAMI FLOWERS

23 BLOOMS TO FOLD

ANCA OPREA

LARK

LARK

An Imprint of Sterling Publishing
387 Park Avenue South
New York, NY 10016

ISBN 978-1-4547-0812-4

Library of Congress Cataloging-in-Publication Data

Oprea, Anca.
 Beautiful origami flowers : 23 blooms to fold / Anca Oprea.
 pages cm
 Includes index.
 ISBN 978-1-4547-0812-4
 1. Origami. 2. Flowers in art. I. Title.
 TT870.O3975 2014
 736'.982--dc23
 2013027530

Distributed in Canada by Sterling Publishing
c/o Canadian Manda Group, 165 Dufferin Street
Toronto, Ontario, Canada M6K 3H6
Distributed in the United Kingdom by GMC Distribution Services
Castle Place, 166 High Street, Lewes, East Sussex, England BN7 1XU
Distributed in Australia by Capricorn Link (Australia) Pty. Ltd.
P.O. Box 704, Windsor, NSW 2756, Australia

For information about custom editions, special sales, and premium and corporate purchases, please contact Sterling Special Sales at 800-805-5489 or specialsales@sterlingpublishing.com.

Email academic@larkbooks.com for information about desk and examination copies.
The complete policy can be found at larkcrafts.com.

Every effort has been made to ensure that all the information in this book is accurate. However, due to differing conditions, tools, and individual skills, the publisher cannot be responsible for any injuries, losses, and other damages that may result from the use of the information in this book.

Manufactured in China

2 4 6 8 10 9 7 5 3 1

larkcrafts.com

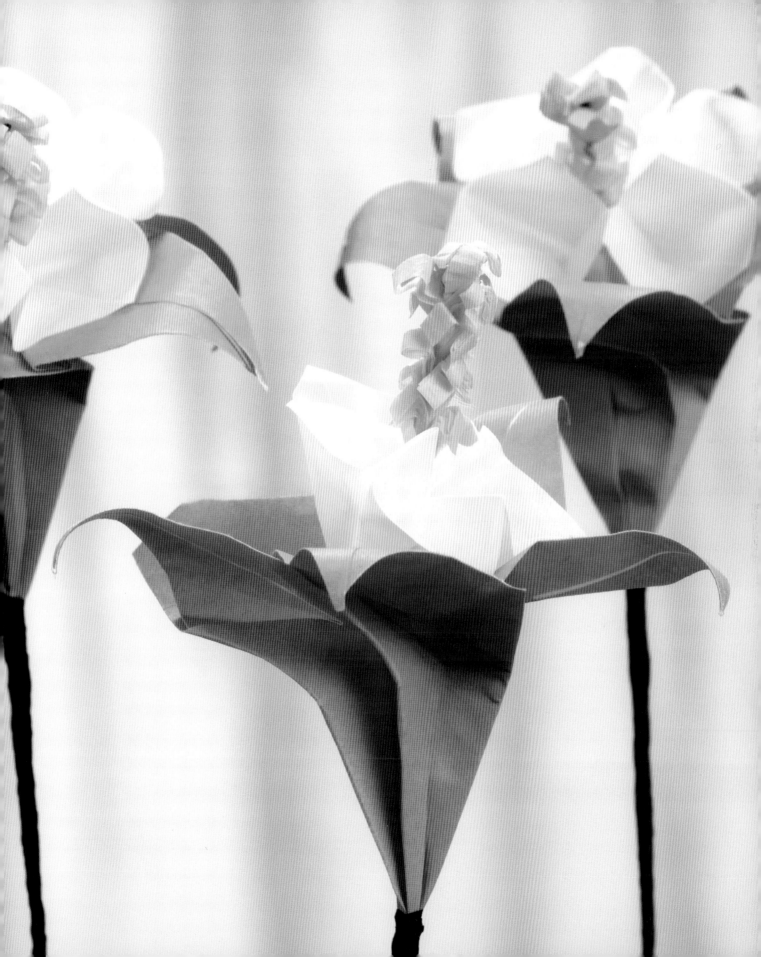

CONTENTS

THE FLOWERS

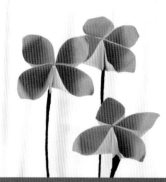

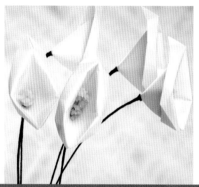

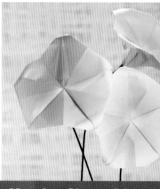

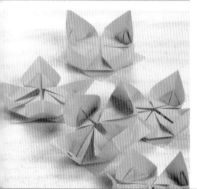

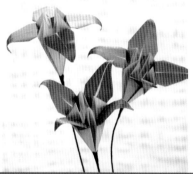

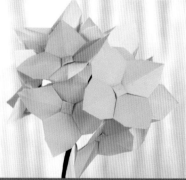

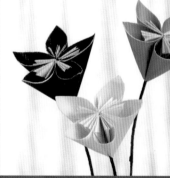

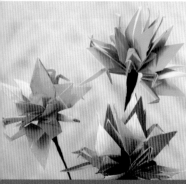

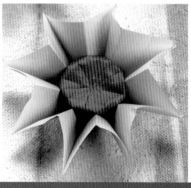

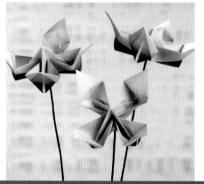

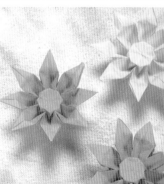

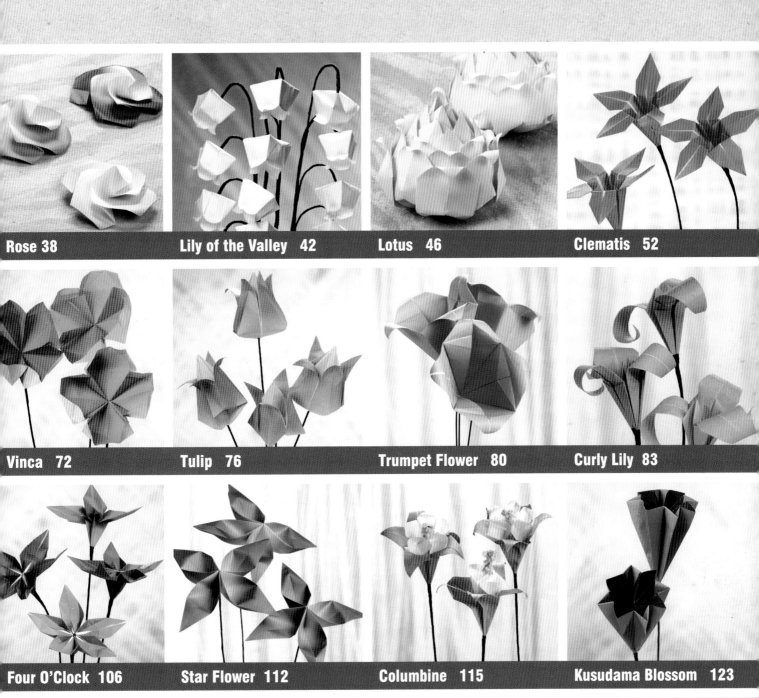

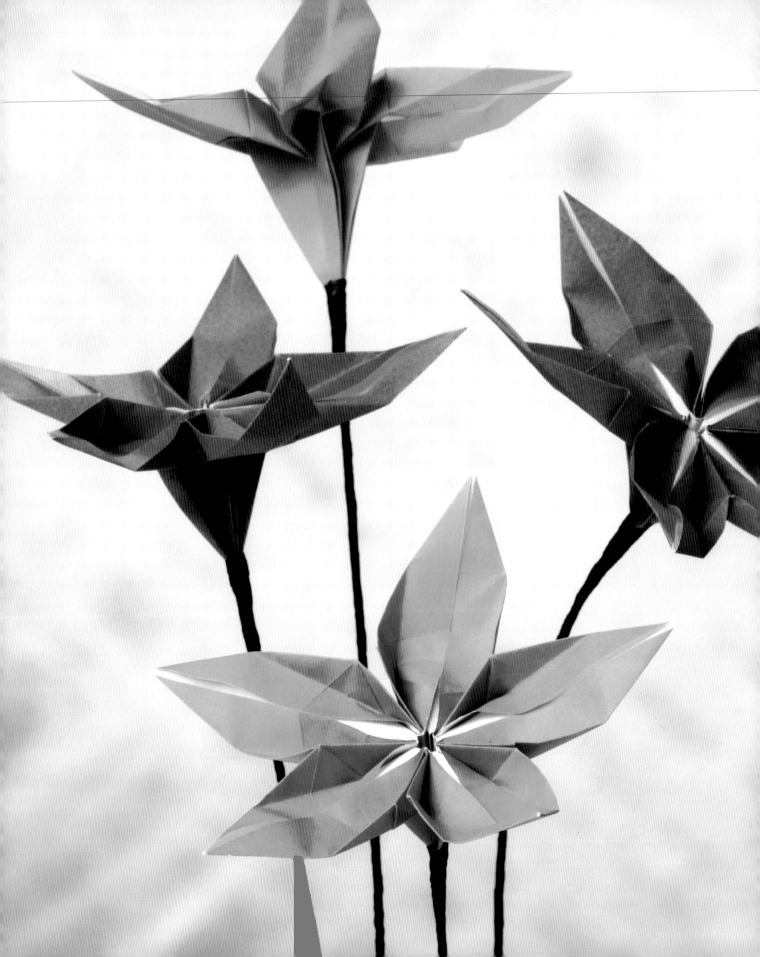

INTRODUCTION

My fascination with origami began while I was teaching school in Romania. I needed a fun way to keep 20 students occupied, and it seemed like the perfect solution. We made origami tulips and butterflies, and they turned out beautifully.

When I moved to the United States five years ago, I had access for the first time to a wide range of origami supplies. I'm now completely captivated by the ancient art of paper folding. It's a meditative yet creative practice that can be incredibly rewarding.

It's also a surprisingly versatile craft that accommodates a wide range of design ideas. From baseball mitts and mini helicopters to swords and spinning tops, it seems that almost anything can be made with folded paper. Out of all the wonderful objects, forms, and figures that can be created through origami, I fell in love with flowers. Warm, colorful blossoms have always appealed to me, and I enjoy creating my own bouquets, so origami flowers were a natural fit for me.

One of the first flowers that I learned to fold was the lily. It's one of my favorites. What I like the most about it (and about origami blooms in general) is its symmetry. As you'll soon discover, creating an origami flower involves executing a series of folds in a designated sequence. The folds should be crisp, sharp, and symmetrical. The folding process is orderly and precise, and I've discovered that I enjoy the steady repetition of the task. I think you will, too. The results are well worth it!

I learned to fold all of the flowers in this book over the course of a couple of years. I folded some of them successfully on the very first try and spent months trying to get the hang of others. Along the way, I tore up a lot of paper! The best advice I can give you is to be patient while you work and let the paper speak to you. Let it guide your hands.

Folding flowers changed the way I look at nature. I spotted a columbine in a garden one day and thought to myself, "I could make something similar out of paper." And so I did. (With origami, anything seems possible!) While folded flowers never quite achieve nature's perfection, they make up for the loss by lasting forever. Most of the projects in this book are fairly easy to create, but if you're new to origami, the lily is a good place to start. And practice those folds! In no time, you'll be arranging your very own origami flower bouquet.

Happy folding!
Anca

THE BASICS

In this section we'll cover the materials and tools you'll need and the techniques you'll use to complete the projects. Origami calls for very little in the way of supplies, and the techniques build on themselves, so you can start simple and advance to more complicated projects as you work your way through the book.

MATERIALS AND TOOLS

Most of the flowers in this book just call for paper and floral wire for a stem. Even the more complicated ones don't require much in the way of materials or tools. Here's a rundown of everything you'll need.

Paper

Origami paper is the best choice for folding flowers because it is thinner than regular paper and therefore easier to fold and manipulate. It comes precut in squares of different sizes (the most common sizes are 6 inches [15.2 cm] and 3 inches [7.2 cm]). Use any precut origami paper of your choice unless otherwise specified in the project instructions.

Kami paper is the least expensive, easiest to fold, and most readily available origami paper. It is thin and usually has one side that is a solid color or simple pattern and one side that is blank.

You can also find kami paper that is colored (the same color) on both sides. Projects such as the Bell Flower call for this paper. Other options are paper with a different color on each side and paper that has a solid color on one side and a geometric or abstract pattern on the other. I also like to create flowers using paper with a gradient color pattern where the colors fade gradually from one shade to another or even from one color from another.

Chiyogami, a type of Japanese paper decorated on one side with brightly colored images, such as birds or butterflies, is fun to use for origami, but does not make for very natural looking flowers. Washi, probably the oldest type of

Japanese paper used for origami, is handmade from bark fibers and thicker than chiyogami or kami—its thickness keeps it from holding folds well. All of the projects in this book were made using kami paper.

You can find kami paper in craft stores, many art supply stores, and online. If you want to get started and you don't have origami paper, go ahead and use any paper you have available—just make sure it holds creases well. And if the paper you have is not the color or pattern you desire, use markers to color it.

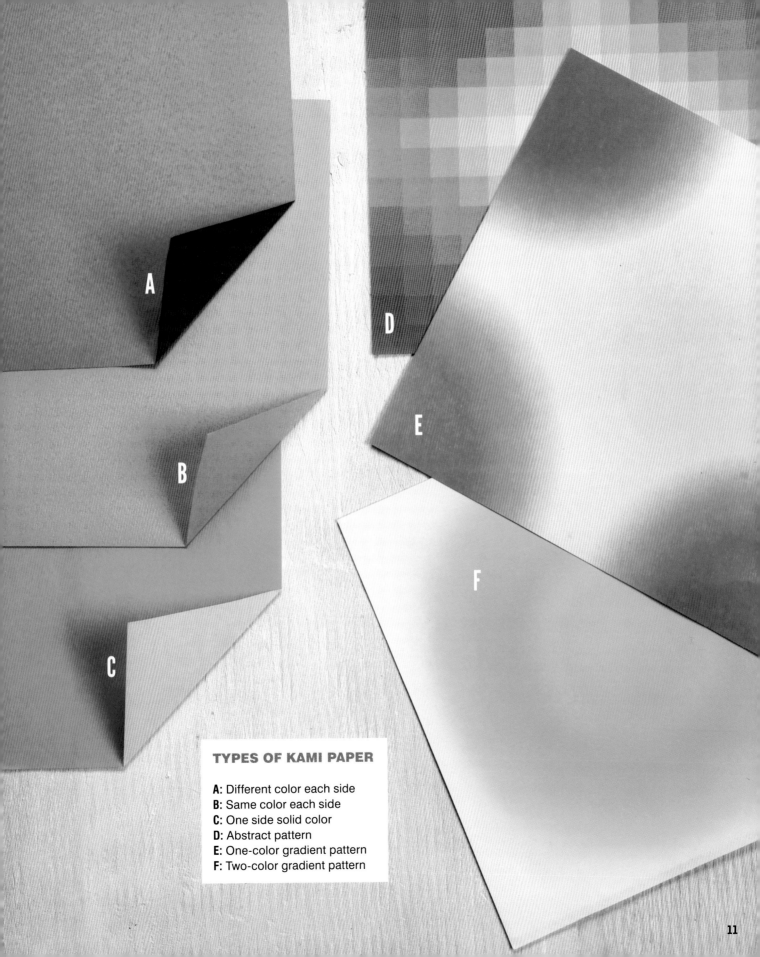

TYPES OF KAMI PAPER

A: Different color each side
B: Same color each side
C: One side solid color
D: Abstract pattern
E: One-color gradient pattern
F: Two-color gradient pattern

Other Tools and Materials

Floral Wire. Ⓐ Ⓑ Easily found in craft stores, floral wire is used for the stems of the flowers in this book. Floral wire comes in various lengths. Thinner floral wire (which usually comes on a spool or reel) is called for in the construction of some of the flowers.

Floral tape. Ⓒ This self-adhesive green or brown tape is used to cover floral wire and is also used in some of the projects to hold multiple strands of thinner floral wire together.

Glue. Ⓓ A few of the projects call for glue. Any paper glue will work well.

Round Bamboo Stick. Ⓔ Use a thin bambo stick (or any wooden skewer) to curl back the tips of petals when making the flowers.

Scissors. Ⓕ You'll need scissors to make some of the paper shapes (triangles, pentagons, and octagons) used as the base for some of the flowers.

Pliers and Wire Cutters. Ⓖ Ⓗ You'll need pliers to curl and bend the floral wire for some of the projects and a pair of wire cutters to cut the wire.

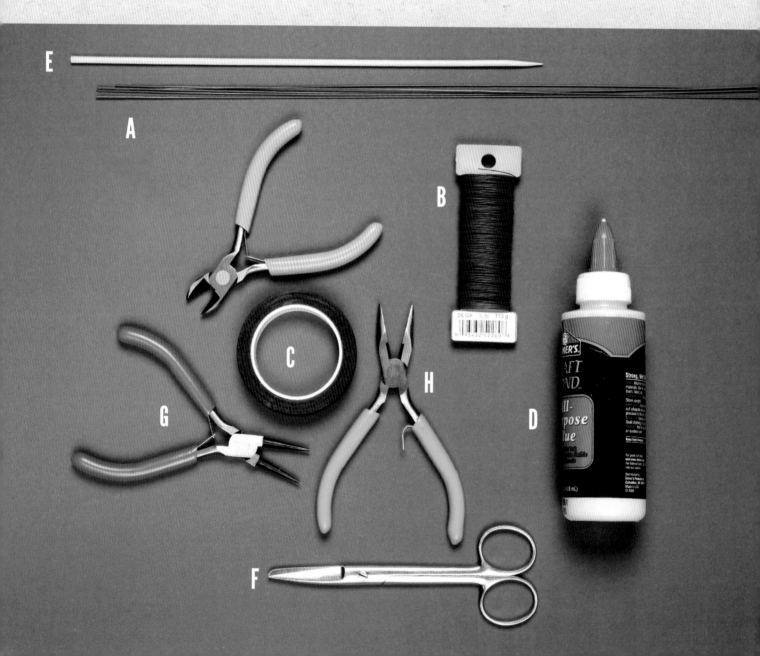

TECHNIQUES

This section will teach you the folds and bases you'll need to make the projects in this book. If you are new to origami, don't just read through this section: Grab some paper and make each fold and each base as you follow the instructions. Becoming confident with folds and bases will make all the difference when it's time to make the flowers.

Origami Folds

Quick and sloppy doesn't work very well in origami. Precise folds and sharp creases are essential for most creations. But don't get frustrated if your first attempts don't look exactly like the photos: Go slowly and practice making accurate folds in the beginning, and pretty soon you'll find yourself doing so automatically each time.

VALLEY FOLD

This is the simplest fold and the one you will use most often as you make the flowers in this book. With a valley fold the paper is folded forward onto itself to create a concave crease (a V, or valley) once the paper is unfolded.

MOUNTAIN FOLD

The mountain fold is just like the valley fold, but instead the paper is folded behind itself to create a convex crease (a peak, or mountain) once the paper is unfolded.

DIAGONAL FOLD

A diagonal fold is simply a valley or mountain fold that goes across the paper diagonally. To make a diagonal fold, fold one corner of the paper to meet the corner diagonally opposite, make sure all the edges align, and crease.

These folds involve reversing (changing the direction of) creases.

INNER REVERSE FOLD

1. Diagonally fold a square sheet of paper. Ⓐ

2. Valley fold the top tip at an angle (any angle will work, but it's best if the tip goes beyond the vertical edge). Ⓑ

3. Unfold the tip and open the paper at the fold. Ⓒ

4. Sink the fold inside on the center crease. Ⓓ

5. Here's how the inner reverse fold looks from the side. Ⓔ

OUTER REVERSE FOLD

The outer reverse fold is similar, but the tip will now be folded back onto the diagonal fold instead of being sunk inside.

1. Mountain fold the top tip at an angle (any angle will work, but it's best if the tip goes beyond the vertical edge). Ⓕ

2. Unfold the paper and fold the tip backwards along the crease you just made. Fold the paper back together. Ⓖ

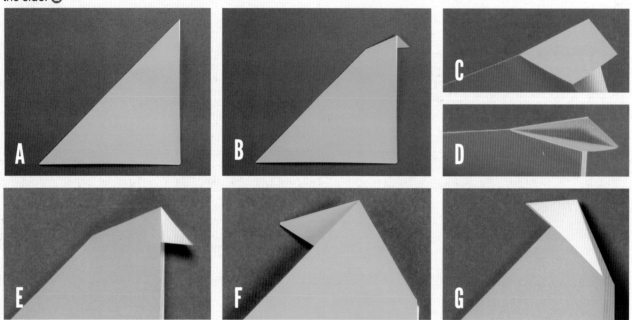

SQUASH FOLD

This common fold is used in many of the projects in the book.

1. This example begins with a square base (page 16). Ⓗ

2. Lift a flap. Ⓘ

3. Open the flap slightly, and then "squash" or flatten it. Ⓙ

4. Carefully align the flap's center crease with the figure's center line or center crease. Ⓚ

PETAL FOLD

The petal fold can be a little difficult until you get the hang of it. The trick is to make sure the lateral flaps align in the center in step 4.

1. Fold the bottom sides of the figure so that they meet at the center line. **L**

2. Open the folds you just made. **M**

3. Begin pulling up on the middle of the figure … **N**

4. While pulling up, close the lateral flaps in completely until they align in the middle. **O**

5. This should create a small triangle at the tip where the two sides meet. **P**

6. Here is the petal fold with the small triangle folded down. The instructions will tell you whether to leave the small triangle pointing up or to fold it down. **Q**

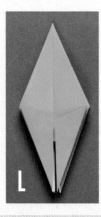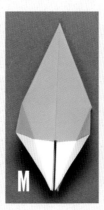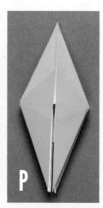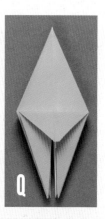

SINK FOLD

A sink fold is a way of collapsing part of a figure to the inside. Getting the hang of it can be tricky so make sharp creases, and take extra time when collapsing the folds. Do it correctly once, and you'll "get" it, and sink folds will become easier!

1. Start with a waterbomb base (page 18). **R**

2. Fold the tip down to meet the center of the bottom edge. Be sure to make a sharp crease. Turn the base over and repeat the crease. **S**

3. Open the base. As you can see, what was the tip of the waterbomb base is now four triangles meeting in the center of a square. **T**

4. Begin collapsing the square by pushing down in the center while pushing the sides in toward the center. **U**

5. This is how the figure will look from above when the tip is sunk. **V**

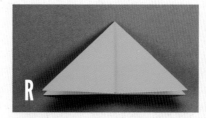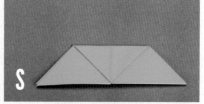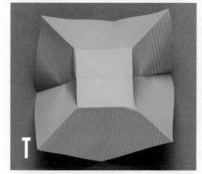

Origami Bases

These bases are the foundation for almost all of the flowers in this book. Take the time to learn to make these bases, and you will have mastered a key skill in origami. While the folds and construction may seem mysterious at first, eventually your fingers will automatically start to fold the required base. Once you understand how a set of folds produces a specific base, origami construction will make more sense to you.

SQUARE BASE

This base is the foundation for many of the flowers in the book. It is a simple one to learn.

Start with the paper colored side down.

Valley fold the paper vertically.

This is how the paper will look when you unfold it.

Valley fold the paper horizontally.

This is how the paper will look when you unfold it.

Turn the paper over so the colored side is up. You'll see that the valley folds are mountain folds on the colored side.

7 Keeping the paper colored side up, valley fold the paper diagonally in one direction.

8 This is what the paper will look like when you unfold it.

9 Valley fold the paper diagonally in the other direction.

10 This is what the paper will look like when you unfold it.

11 Locate the four diamonds (or squares) created by the fold lines.

12 Collapse the paper along the fold lines into a square.

13 This is the completed square base.

1

Start with the paper colored side down.

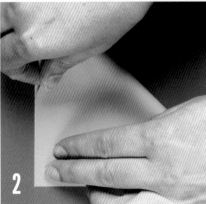

2

Valley fold the paper diagonally in one direction.

3

This is how the paper will look when you unfold it.

7

Valley fold the paper vertically.

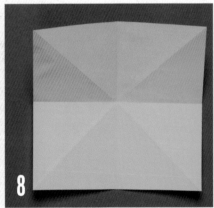

8

This is what the paper will look like when you unfold it.

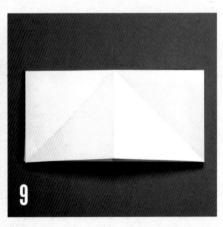

9

Valley fold the paper horizontally.

4 Valley fold the paper diagonally in the other direction.

5 This is what the paper will look like when you unfold it.

6 Turn the paper over so the colored side is up. You'll see that the valley folds are mountain folds on the colored side.

10 This is what the paper will look like when you unfold it.

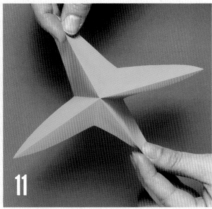

11 Collapse the paper along the fold lines into a triangle.

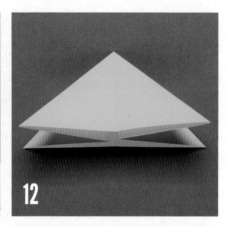

12 This is the completed waterbomb base.

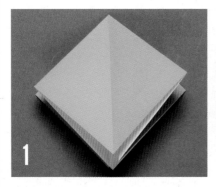

1

Start with a square base (page 16).

2

Lift the right flap.

3

Squash fold (page 14) the flap.

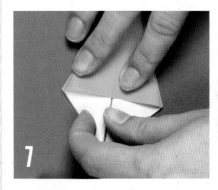

7

Repeat this process of lifting a flap and making a squash fold two more times until all of the flaps have been folded in a squash fold.

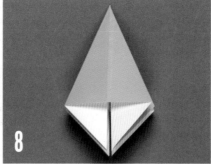

8

This is how the figure should look.

9

Diagonally fold the right bottom corner in to align with the center line as shown in the photo.

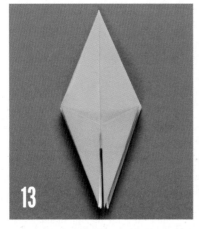

13

Repeat two more times until all of the bottom corners have been folded in diagonally. This is how the figure will look.

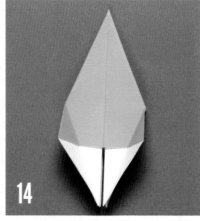

14

Open the set of corners you just diagonally folded.

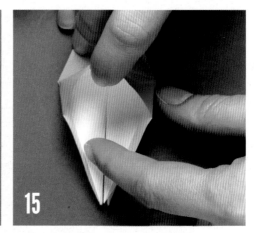

15

Make a petal fold (page 15). Begin by opening the figure by pulling up on the middle flap.

4

Align its center crease carefully with the center line of the figure.

5

Turn the figure over.

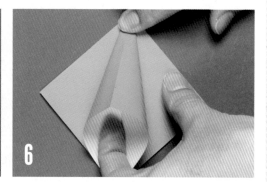

6

Lift the right flap and make a squash fold again.

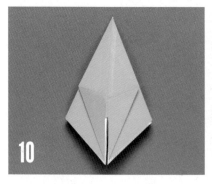

10

Repeat with the bottom left corner.

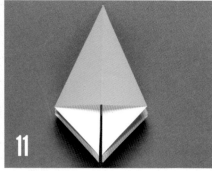

11

Turn the figure over.

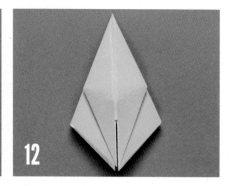

12

Repeat steps 9 and 10.

16

Close the lateral flaps in completely until they align at the center.

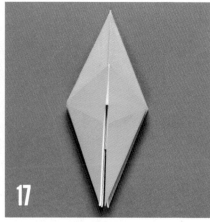

17

This should create a small triangle at the tip where the two sides meet.

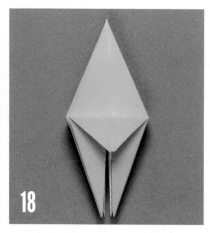

18

Repeat steps 14 through 17 for all sides. Fold down the small triangles. This is the completed frog base.

1 Start with a square base (page 16).

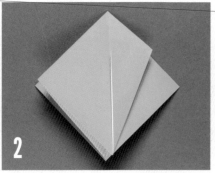

2 To make a petal fold (page 15), first diagonally fold the right side in to align with the center line as shown in the photo.

3 Repeat with the left side.

4 Open the folds you just made.

5 Begin opening the figure by pulling up on the middle.

6 Then close the lateral flaps in.

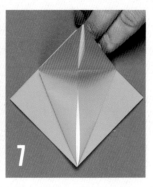

7 The flaps should align at the center.

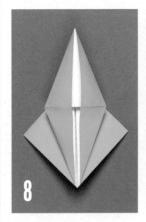

8 This should create a triangle at the top where the two sides meet.

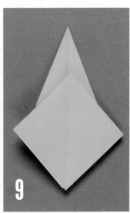

9 Flip the figure over.

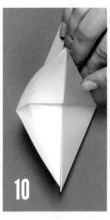

10 Repeat steps 2 through 7.

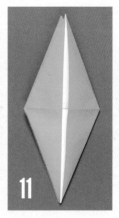

11 Repeating steps 2 through 7 creates another triangle at the top where the two sides meet.

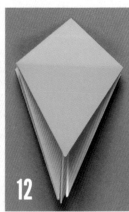

12 Fold the top flaps down so the smooth sides are on the front and the back. This is the completed bird base.

Other Geometric Shapes

Some of the projects in this book start with a triangular, pentagonal, or octagonal sheet of paper instead of the usual square one. No problem: You can make each of these shapes from a square sheet simply by folding and cutting.

MAKE A TRIANGLE

1 Fold the paper in half horizontally and unfold.

2 Fold the top right corner down until it meets the center crease you just made.

3 Fold the top left corner down until it meets the center crease.

4 Cut along the diagonal creases.

5 You will then have an equilateral trangle.

1 Start with a square sheet of paper, colored side down. Valley fold the top edge of the paper down to meet the bottom edge to create a rectangle.

2 Fold the rectangle vertically in two, but do not make a full crease; instead, simply make a small crease to mark the center of the bottom of the rectangle.

5 Repeat steps 3 and 4 with the lower right corner. You now have an X-shaped crease marking the middle of the right half of the rectangle.

6 Turn the paper 180 degrees.

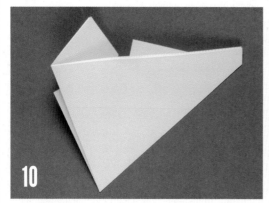

10 Flip the figure over.

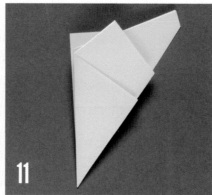

11 Make a valley fold through the middle of the structure. The figure should look like the photo.

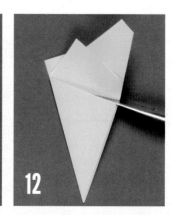

12 Use scissors to cut off the top of the figure as shown.

3 Now fold the top right corner of the rectangle so it overlaps the center line. Again, don't make a full crease.

4 Simply make a small crease to mark the middle of the fold.

7 Fold the right lower corner and bring it to the center of the X as shown in the photo, making a sharp crease.

8 Fold the corner that is positioned on the center of the X over to the right to align with the diagonal exterior line, and make a sharp crease. The figure should look like the photo.

9 Fold the lower right corner of the figure to the right to align with the diagonal interior lateral line formed by the previous crease. Make a sharp crease. Your figure should look like the photo.

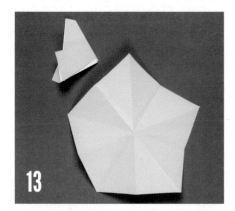

13 Open up the paper, and you will have a pentagon.

1 Start with a square base (page 16).

2 Lift the right flap.

3 Squash fold (page 14) the flap, aligning its center crease carefully with the center line of the figure.

4 Repeat steps 2 and 3 for all flaps.

5 Cut off the white part at the bottom.

6 You now have an octagon.

THE PROJECTS

BEGINNER

Cupped Flower
Calla Lily
Morning Glory
Rose
Lily of the Valley
Lotus

INTERMEDIATE

Clematis
Anemone
Day Lily
Hydrangea
Passion Flower
Vinca
Tulip
Trumpet Flower
Curly Lily
Crane Flower

ADVANCED

Gerber Daisy
Hollyhock
Cosmos
Four O'Clock
Star Flower
Columbine
Kusudama Blossom

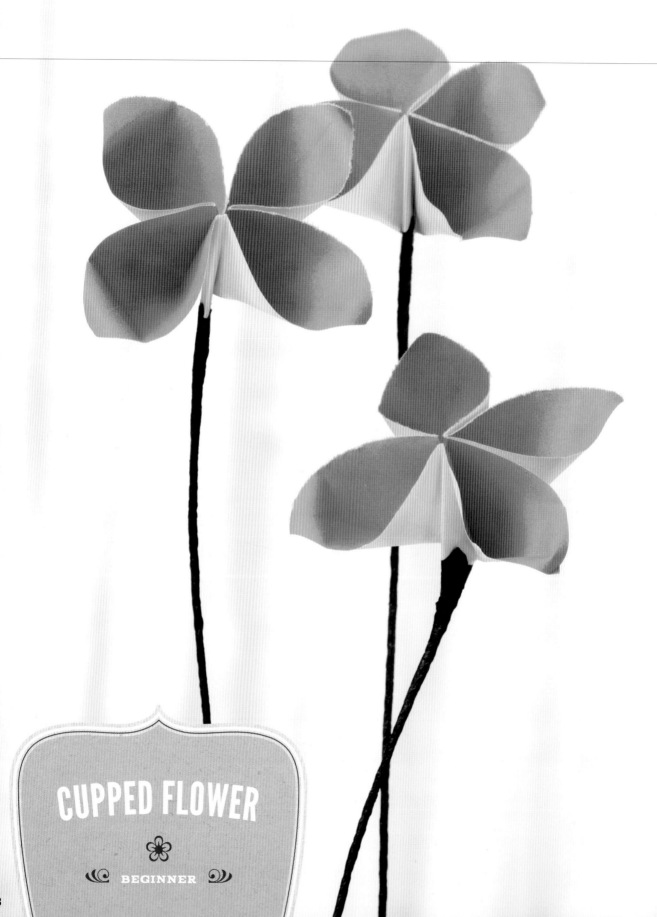

CUPPED FLOWER

❀

BEGINNER

HOW YOU FOLD IT ▷

NOTE: THE FLOWERS SHOWN WERE MADE WITH 3-INCH-SQUARE (7.6 CM) SHEETS OF ORIGAMI PAPER.

1

Start with a waterbomb base (page 18) with the colored side on the inside.

2

Fold the triangle shape in half (right side over left side), so that the four smaller triangles form one right-angle triangle with open ends at the bottom.

3

Diagonally fold the right side of the triangle about ¼ inch (6 mm) over the center. Make sure the crease is strong—this will be your stem.

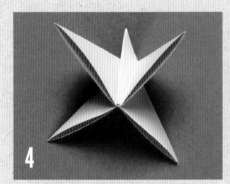

4

Carefully open the figure up a bit to reveal the four petals.

5

Holding the flower at the small stem you created, use your thumb to open the four petals.

6

This is how the completed flower should look.

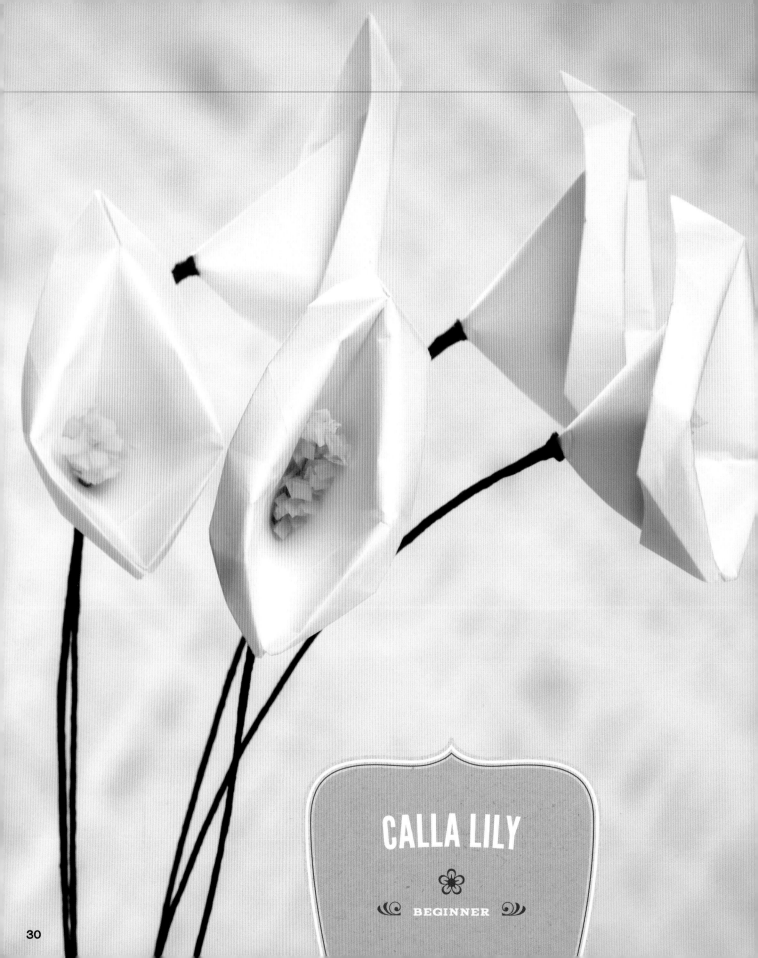

CALLA LILY

BEGINNER

HOW YOU FOLD IT ➤

NOTE: TO COMPLETE THIS PROJECT, YOU WILL NEED A WHITE SHEET OF ORIGAMI PAPER, A 4-INCH-LONG (10.2 CM) STRIP OF YELLOW TISSUE PAPER, A FLORAL WIRE STEM, FLORAL TAPE, SCISSORS, AND GLUE.

1

Follow the steps for Making the Stamen on page 33 to make the stamen part of the calla lily. Set the completed stamen aside.

2

Fold the white paper diagonally to divide it into four triangles. Position the paper as shown.

3

Fold the top tip of the paper so it meets the creases in the center of the paper.

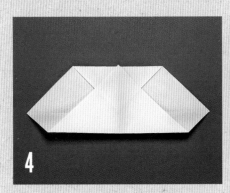

4

Fold the bottom tip of the paper so it meets the center crease at the top of the figure.

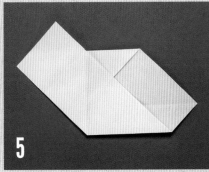

5

Fold the left side of the figure diagonally so that what was the bottom edge now meets the vertical center crease.

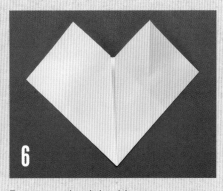

6

Repeat on the right side.

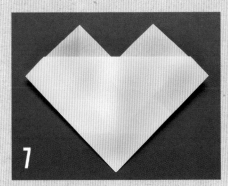

7

Flip the paper over.

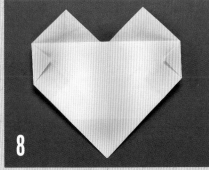

8

Fold each side corner in as shown.

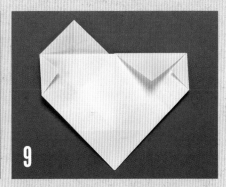

9

There are two triangles at the top of the figure. Fold the right triangle down as shown.

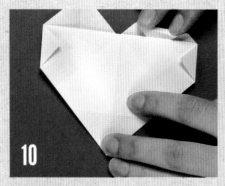

10

Lift the triangle back up and tuck it inside the figure as shown.

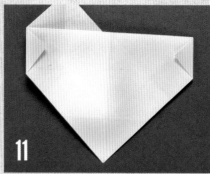

11

This is how the figure should look.

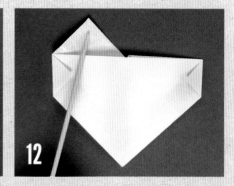

12

Spread glue on the still-open triangular flap.

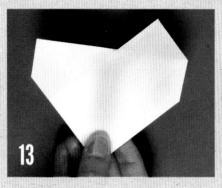

13

Lift the paper and turn it over.

14

Gather the base lines of the figure together so that the glued flap is on the inside of the flower and the two small triangle folds are on the outside.

15

Press the parts together until the glue holds.

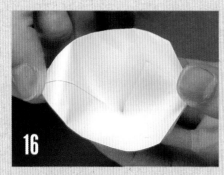

16

Curl back the top point of the cup.

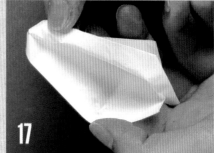

17

Use your thumb to fold over the outer edge of the cup, creating a collar around it.

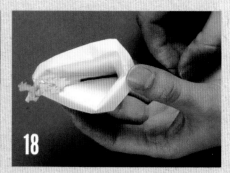

18

Insert the stamen through the center of the flower as shown and then wrap the stem using floral tape where it meets the flower.

MAKING THE STAMEN

1

Valley fold the strip of yellow tissue paper in half horizontally.

2

Valley fold the top (folded) edge of the figure.

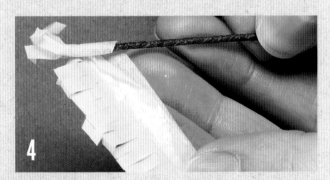

3

Make small cuts along the folded top edge. The cuts should go just slightly past the bottom edge of the fold.

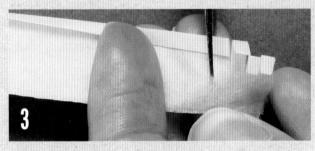

4

Turn the paper over. Apply glue to the bottom edge of the strip. Slowly wrap the yellow strip around the floral-tape-wrapped end of the wire stem.

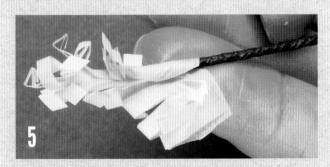

5

Slowly spiral the strip down the floral wire stem.

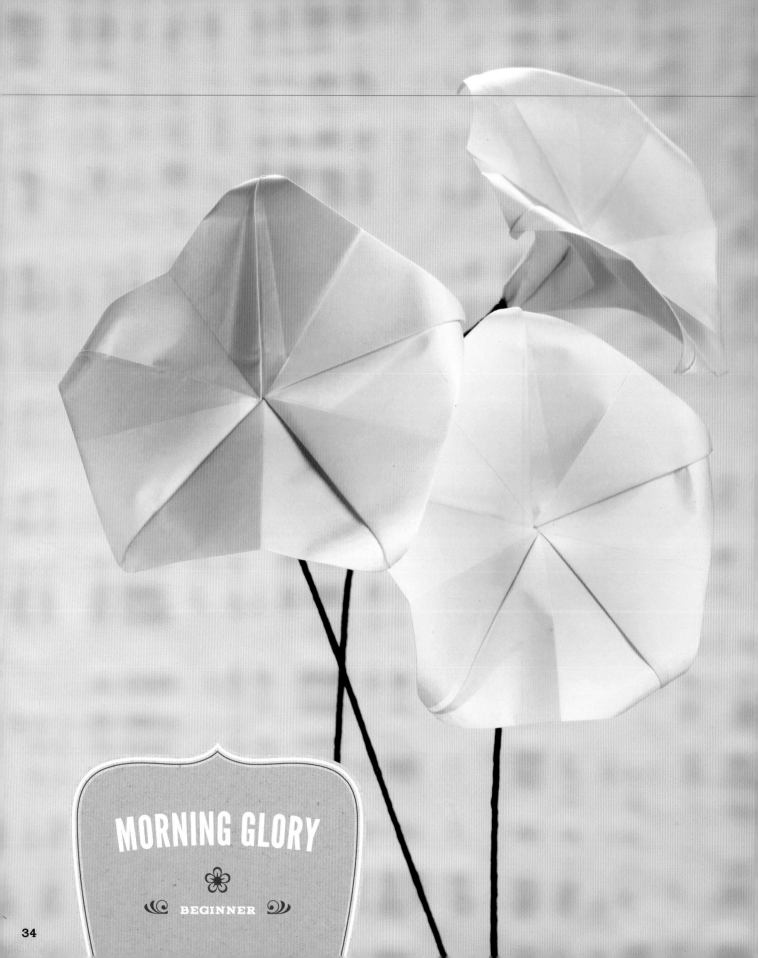

MORNING GLORY

❁

⟪ BEGINNER ⟫

1 Start with a basic square base, colored side on the inside.

2 Fold the right corner of the base to meet the center crease on the left side.

3 Repeat on the left corner of the base.

4 Turn the figure over and repeat steps 2 and 3. The new structure should be a diamond shape.

5 Lift up one of the diamond's side triangles.

6 Open it and then flatten it with a squash fold (page 14), making sure its center crease aligns with the center of the figure.

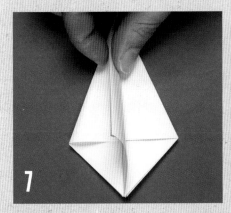

7 Lift the flap on the right side of the figure.

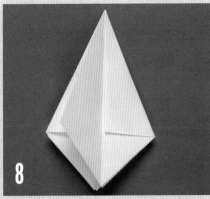

8 Fold the flap over to the left.

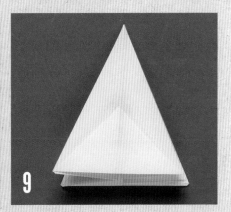

9 The figure now has four small triangles at the bottom. Fold each of these triangles up in a valley fold.

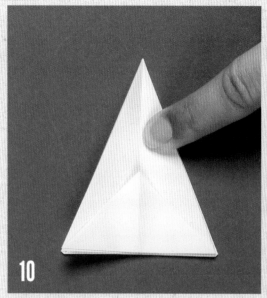

10

Locate the point one-third of the way down from the figure's tip. This is the point at which the bloom will open.

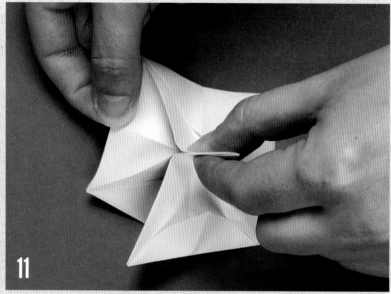

11

Keeping a tight grip at this point, turn the figure upside down over a hard surface and gently push the petals open.

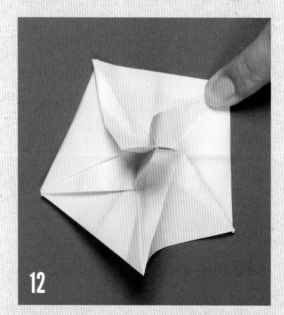

12

As you are pushing down the petals to open them up, make sure that the backs of the petals are all aligned in one direction (in the picture they are aligned counter-clockwise).

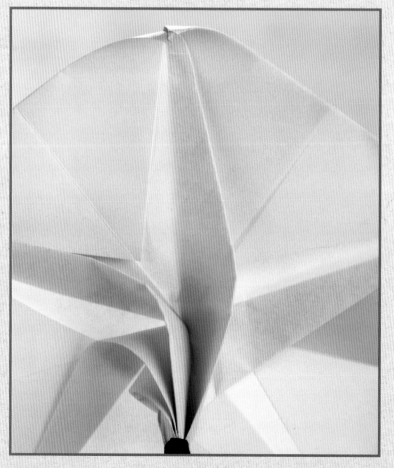

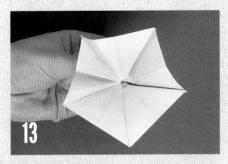

13

When you turn the flower over, it should look like this.

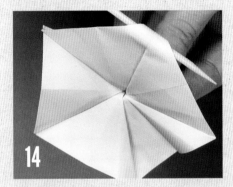

14

Use a bamboo stick to curl back each of the flower's five corners.

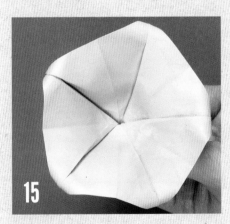

15

Gently insert your thumb into the center of the flower to create a small hole to give it a three-dimensional effect.

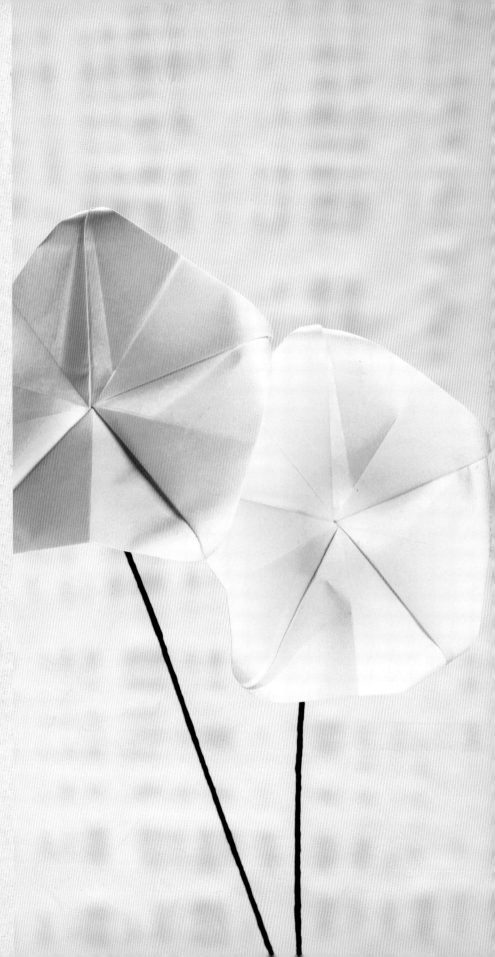

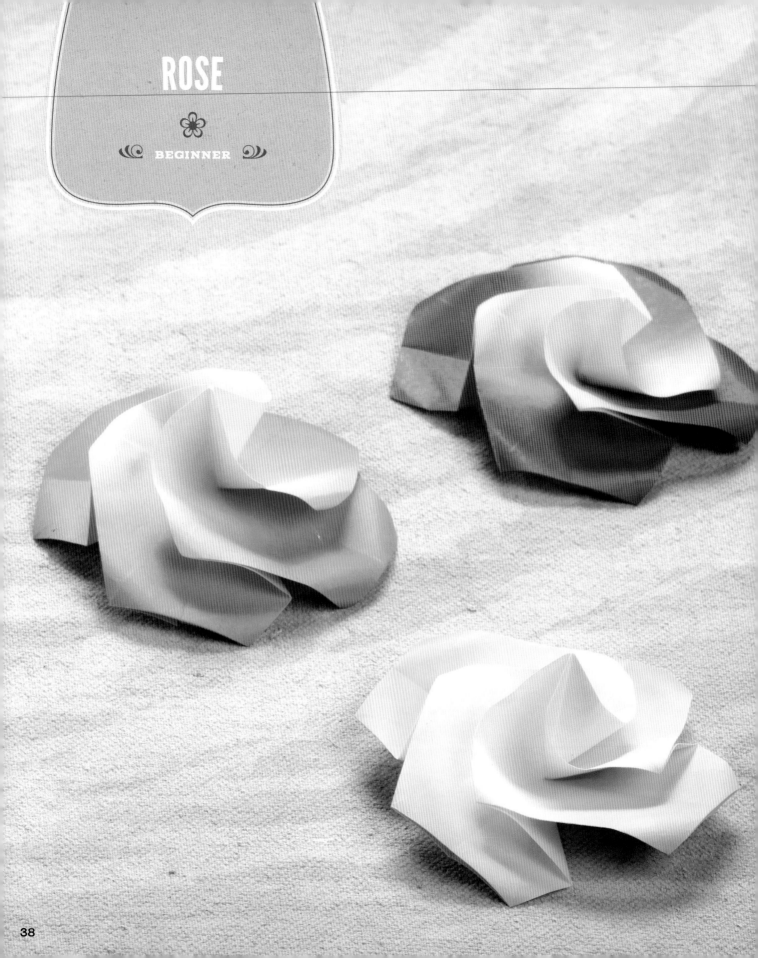

ROSE

❁

◖ BEGINNER ◗

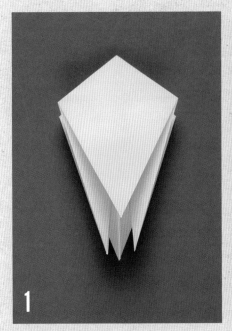

1 Start with a bird base (page 22).

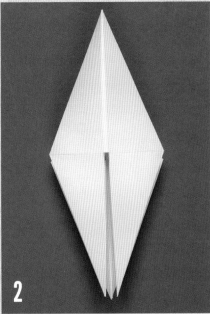

2 Lift the bottom tip and open the base as shown.

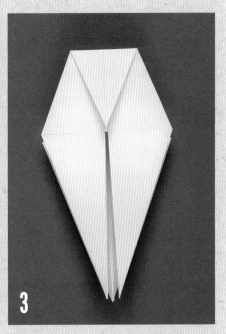

3 Fold the top tip toward the middle and crease.

4 Lift the tip back up, and open the flaps.

5 Fold the tip down inside as shown.

6 Fold the tip along the crease made in the previous step.

7

Repeat steps 2 through 6 for the three remaining sides. When you're done, the figure should look like this.

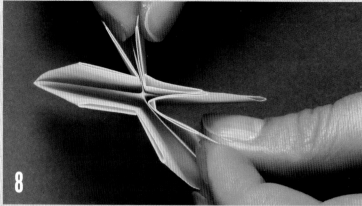

8

Look inside the shape, and you'll see a raised tip in the center and four folded flaps. This raised tip will become the center of the rose, and the flaps will form the petals.

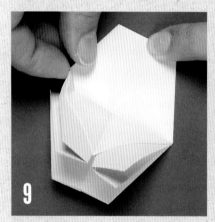

9

Holding the figure against a flat surface, flatten one flap.

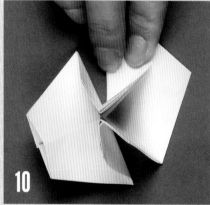

10

Bring the edge of the next flap over to the left to meet the center crease in the first flap and fold.

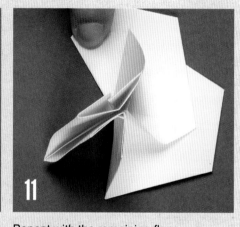

11

Repeat with the remaining flaps.

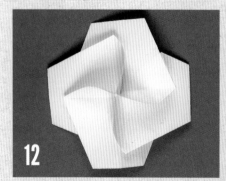

12

This is how the figure should look.

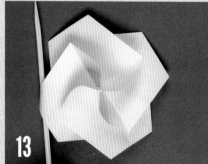

13

Curl the edges of each flap with a bamboo stick.

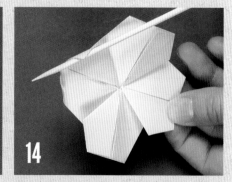

14

This is how the back of the flower should look as you are curling the edges.

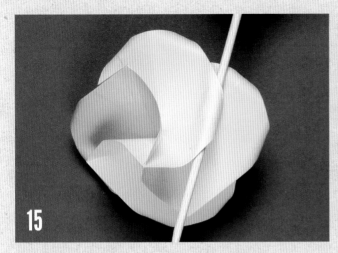

15

As you curl each edge, the shape will become slightly distorted. Don't worry about that—you'll fix it in the next step.

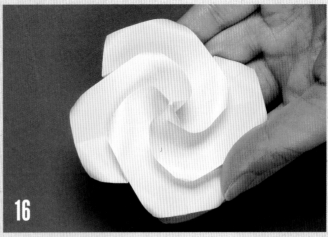

16

Use your fingers to push the shape back down, twisting it slightly around the center point as you do so to obtain a nice rose shape.

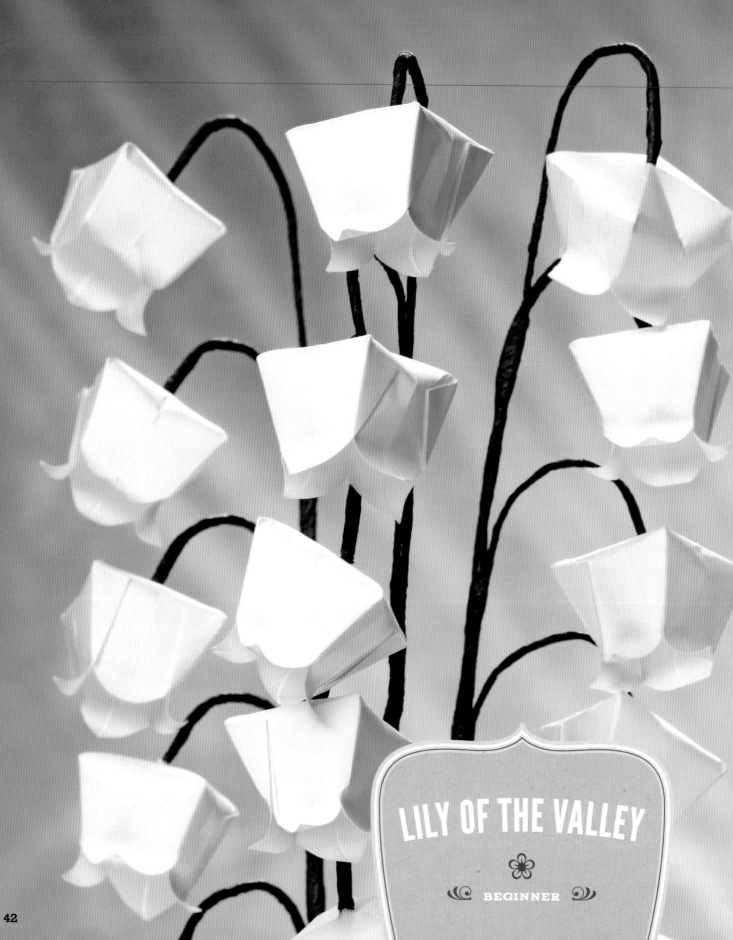

LILY OF THE VALLEY

BEGINNER

HOW YOU FOLD IT

NOTE: TO MAKE EACH SPRIG OF FLORETS, YOU'LL NEED FIVE SHEETS OF 2-INCH-SQUARE (5.1 CM) WHITE PAPER, PAPER GLUE, THIN FLORAL WIRE, AND FLORAL TAPE. YOU'LL ALSO NEED A PAIR OF ROUND-NOSE PLIERS TO SHAPE THE WIRE.

1

Begin by folding one 2-inch (5.1 cm) square of paper as you would to make a square base (page 16), but don't fold the paper into the base yet; instead, leave the paper open.

2

Fold the exterior corner of one square to bring it to the center of the square as shown.

3

Repeat step 2 for all corners. When you're done, you should have a smaller square of paper with four triangular flaps on the facing side.

4

Collapse this square into a square base, making sure the triangular flaps are on the inside of the base.

5

Using the photo as a guide, fold about ¼ inch (6 mm) of each side corner in toward the middle.

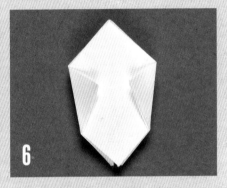

6

Repeat step 5 for all sides, making sure the creases are as sharp as possible. This is how the structure should look when you are done with the side folds.

7

For extra security, apply paper glue to the inside of the flaps you just made.

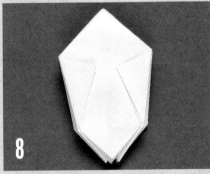

8

Then refold the flaps and allow the glue to dry.

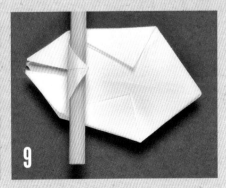

9

Use a bamboo stick to curl back the tip of each petal.

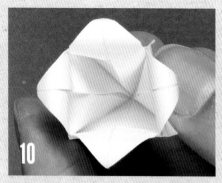

10

As you curl back the tip of each petal, you will also open up the flower.

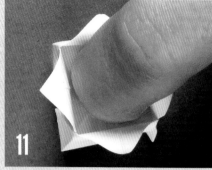

11

After curling the tip of the petals, gently push down the inside base of the floret.

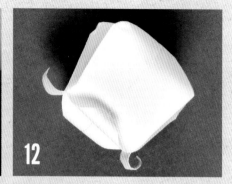

12

Here's how the completed floret looks from the side.

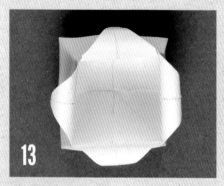

13

Here's how it looks from the top.

14

Cut a 4-inch (10.2 cm) length of thin floral wire and use the round-nose pliers to form a small loop on one end.

15

This is how the completed loop should look.

16

Poke the plain end of the wire through the center inside bottom of the floret and then pull the wire very gently until the loop catches. Wrap the top few inches of wire outside of the floret with floral tape.

17

Bend a curve into the top of the wire as shown.

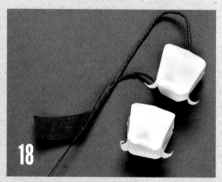

18

Gather stems of florets as shown and wrap the stems with floral tape. Continue wrapping until all five stems create one sprig of lily of the valley.

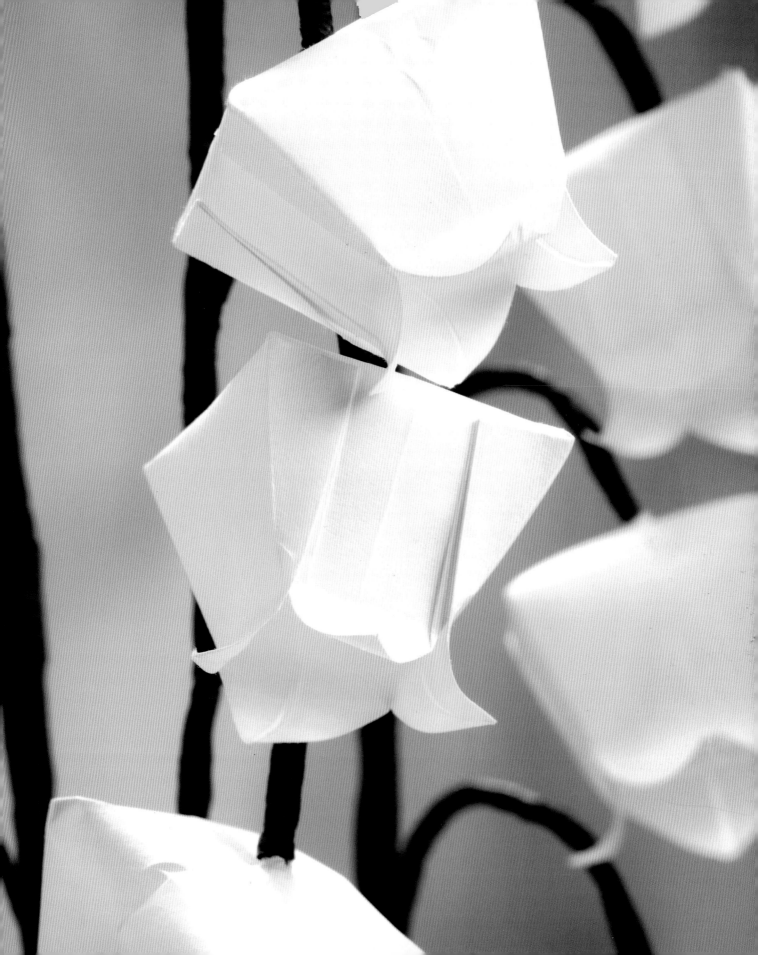

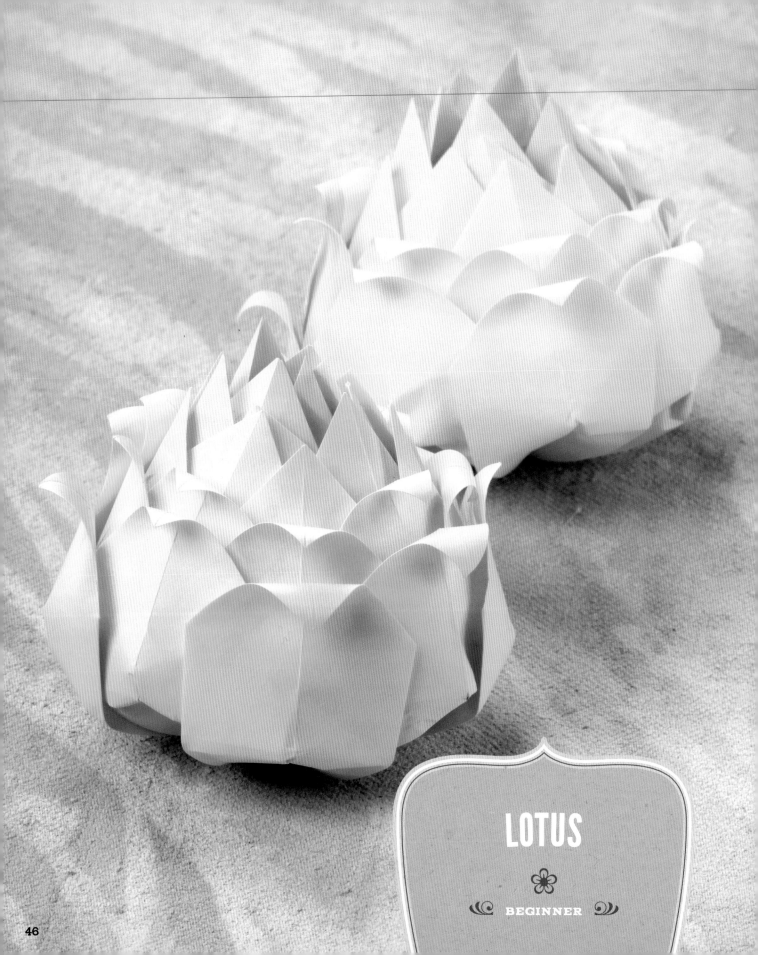

LOTUS

❀

BEGINNER

HOW YOU FOLD IT

NOTE: FOR THIS FLOWER YOU WILL NEED EIGHT SHEETS OF PAPER THAT HAVE BEEN CUT OR TORN IN HALF TO MAKE 16 RECTANGLES OF PAPER AND 4 INCHES (10.2 CM) OF THINNER FLORAL WIRE.

1

Start with one rectangle of paper colored side down. Arrange it as shown with the longer sides horizontal.

2

Make a valley fold horizontally, and crease. When opened, the paper should have a crease through the middle, dividing it into two thinner rectangles.

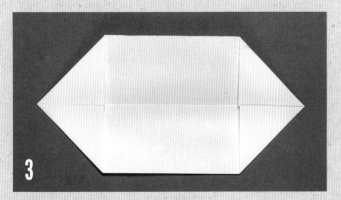

3

Fold each corner down diagonally to bring it toward the center crease as shown.

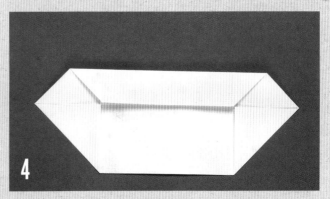

4

Fold the top of the figure down with a valley fold to align it with the center crease.

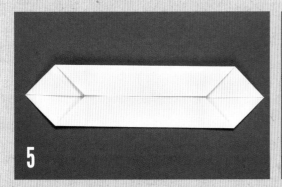

5

Fold the bottom of the figure up with a valley fold to align it with the center crease.

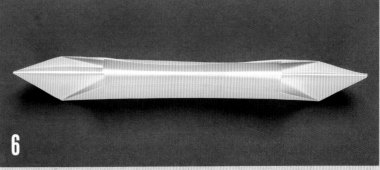

6

Fold the entire figure horizontally at the center with a mountain fold. The finished figure should look like the photo.

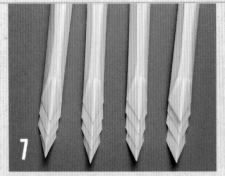
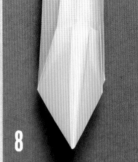

7

Repeat steps 1 through 6 for the remaining 15 sheets of paper. When you are done, you will have 16 figures. Group them into four units of four by placing one figure on top of another, making sure the flaps of each bottom unit are completely tucked in.

8

Check once more to make sure all the flaps are completely tucked in, and then align all the units in each group as shown in the photo.

9

Carefully gather all four units and use the floral wire to tie the groups together in the middle.

10

Be sure to leave plenty of wire for a stem.

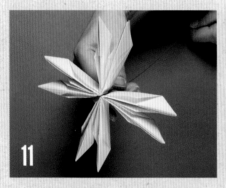
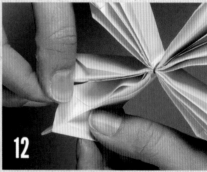
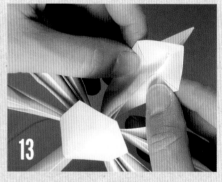

11

You now have eight groups that are four layers (petals) thick. Begin separating the groups as shown.

12

Open the top layer of each group by pulling the tip of the petal in toward the center.

13

Once you've opened one petal by pulling it all the way in toward the center, open the top petal of the opposite group.

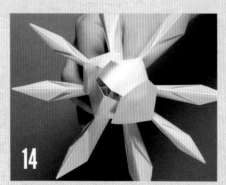
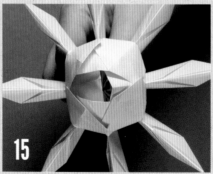
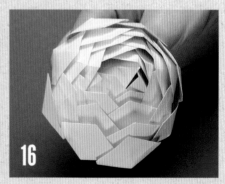

14

Continue opening petals around the flower, remembering to open the top petal from the opposite group each time.

15

The first layer is now opened.

16

Continue opening each layer of each group until the entire flower is opened.

17

Use a bamboo stick to curl each petal tip back, starting on the outermost layer and again working on opposite petals each time.

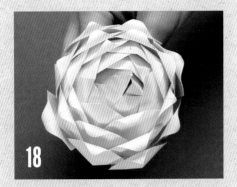

18

Curl two or three layers of petals to give the flower dimension.

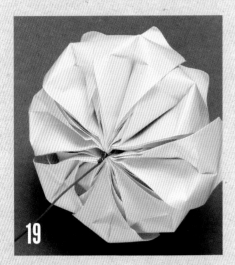

19

This is how the back of the finished lotus will look.

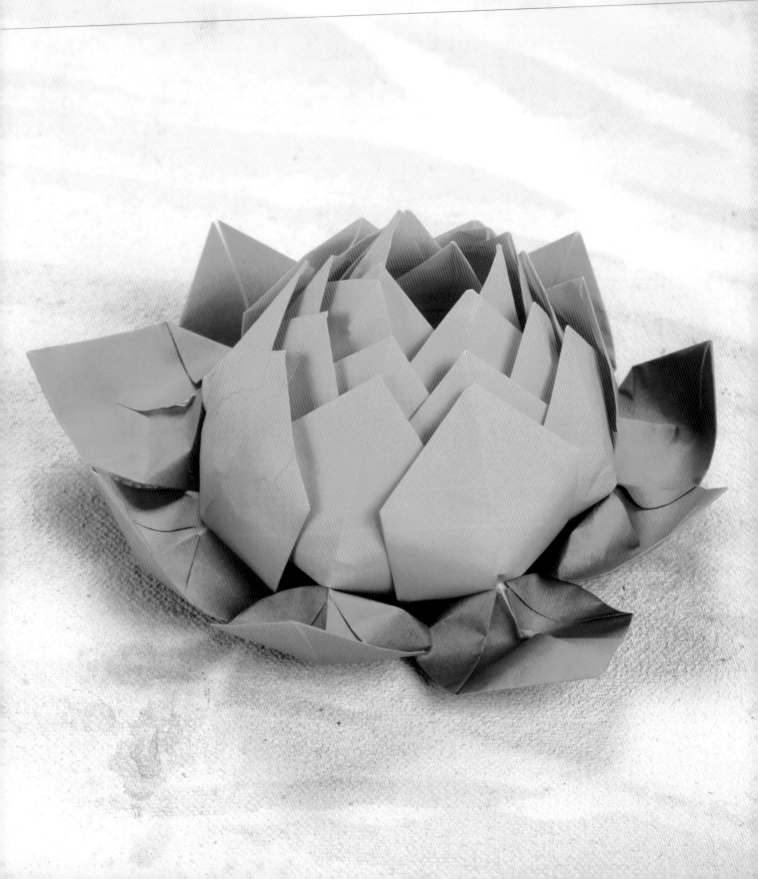

TO MAKE A LOTUS WITH LEAVES

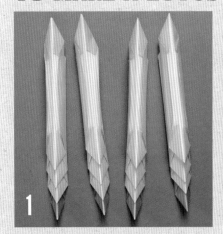

Lotus flowers with leaves can be made using the same technique. Start with two green papers and six orange papers that have been cut in half. When you arrange the four units of four figures, make sure you start with a green figure at the bottom of each unit.

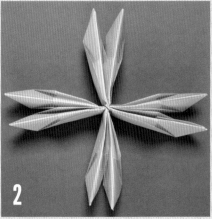

Once you've connected the units with floral wire, the flower will look like this from the top.

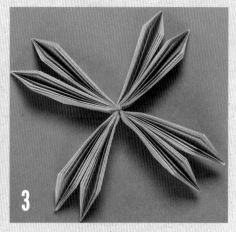

This is what it looks like from the bottom.

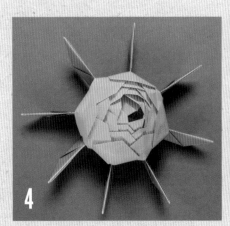

Use the same technique as for the leafless lotus to open the petals.

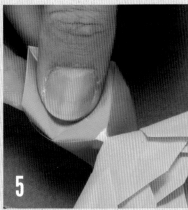

To open a leaf, pull it up only halfway then flatten it toward its base.

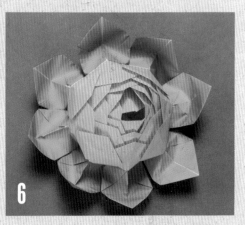

Continue opening opposite leaves until the flower is complete.

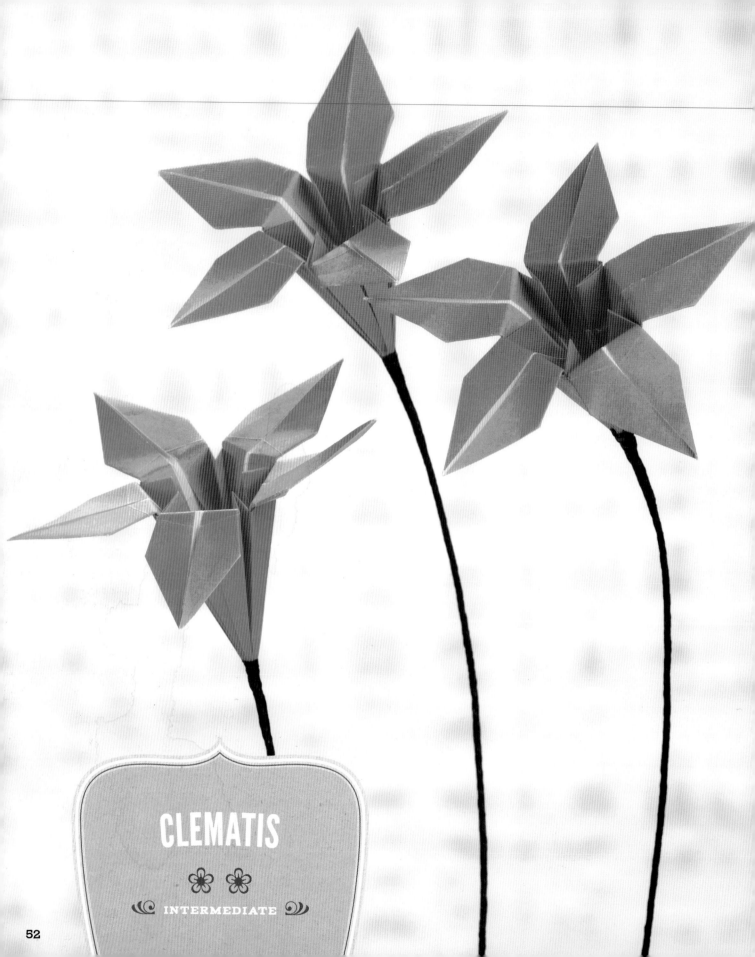

CLEMATIS

✿ ✿

❦ INTERMEDIATE ❧

1

Follow the steps on page 24 to make a pentagon.

2

Fold the pentagon into a diamond shape by collapsing it as shown in the photo.

3

The open end of the figure should be at the bottom as shown in the photo.

4

Lift one flap up.

5

Open the flap and then flatten it down in a squash fold (page 14), making sure its center crease aligns with the center of the figure.

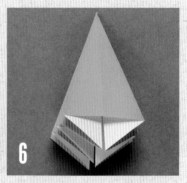

6

Repeat on all sides. When you are done, the figure should look like the slimmer diamond shape shown in the photo.

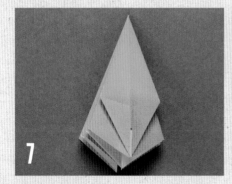

7

To create a petal fold (page 15), valley fold the bottom sides of the diamond so that they meet at the centerline as shown in the photo.

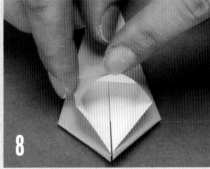

8

Open the folds you just made. Begin pulling up on the middle of the figure.

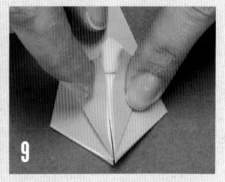

9

Then close the lateral flaps in completely until they align in the middle.

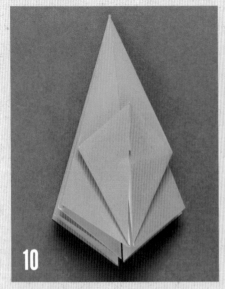

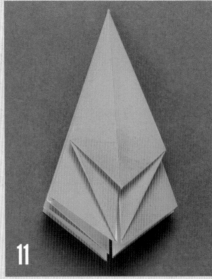

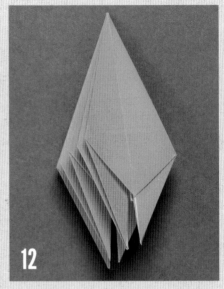

10 This should create a small triangle at the tip where the two sides meet.

11 Fold down the tip.

12 Repeat steps 7 through 11 for all remaining sides.

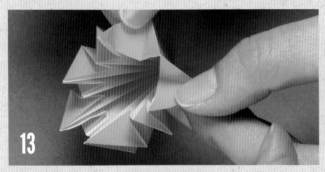

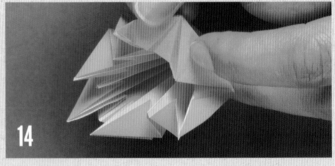

13 When you're done, open the figure partly by pulling on the two top base tips. The top of the figure should have taller and smaller tips. The smaller tips will be folded into the center of the figure on their precreased lines.

14 To fold in the first small tip, lift the center of the smaller tip between the base triangles to unfold it.

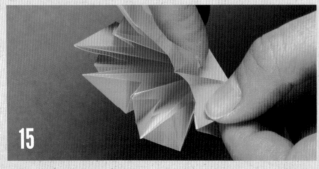

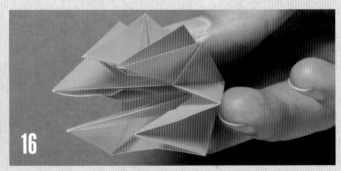

15 Then refold it in on itself.

16 Tuck it in between the two base triangles.

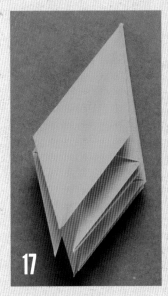

17

Repeat for all sides.

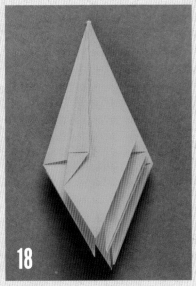

18

Close the figure back into a diamond shape with smooth sides and crease it sharply. Diagonally fold the top left flap in to meet the center crease as shown in the photo.

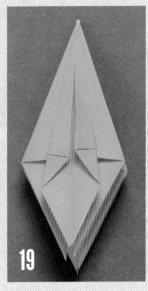

19

Repeat with the right top flap.

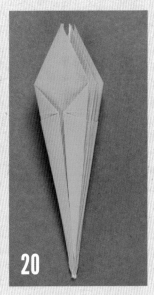

20

Flip the figure over and repeat steps 18 and 19, then repeat for all smooth sides. Position the figure so it is open at the top.

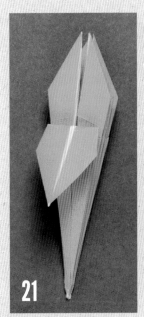

21

Open one petal by folding it down toward the closed tip of the figure.

22

Repeat for all remaining petals.

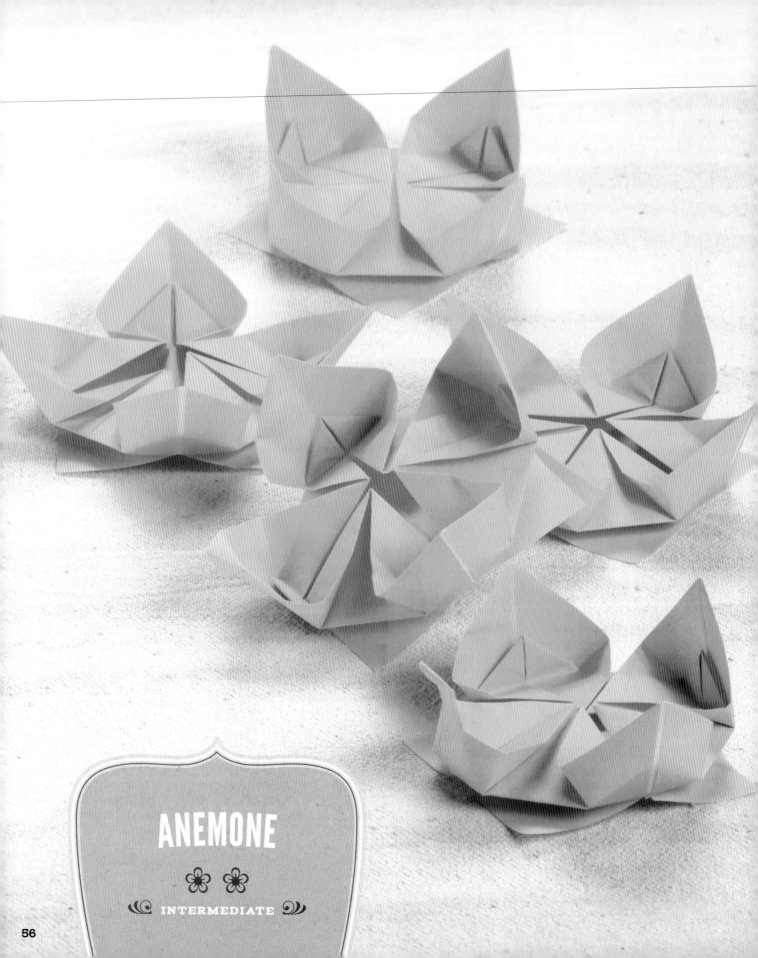

ANEMONE

❀ ❀

‹‹❧ INTERMEDIATE ❧››

HOW YOU FOLD IT

1

Start with the paper colored side down.

2

Fold it in half diagonally, turn it 90 degrees and fold it in half diagonally again.

3

Fold the upper right corner into the center of the paper as shown.

4

Repeat for the other three corners. Turn the figure so it is a square instead of a diamond. This is how the figure should look with all corners folded to the center.

5

Fold the upper right corner into the center of the figure again, as shown.

6

Repeat for the other three corners. Turn the figure so it is a square instead of a diamond. This is how the figure should look with all of the corners folded to the center once again.

7

Fold all of the corners into the center for a third time. Then turn the figure over.

8

With the figure turned over, repeat the process of folding all the corners into the center. By now, the layers of paper will make it harder to fold, so be sure to make the creases as sharp as possible.

9

Open all the folds you made in step 8.

10

Turn the figure over.

11

Fold each triangular flap down in a valley fold and then back up in a mountain fold, leaving a border of about ¼ inch (6 mm) as shown.

12

Repeat for all triangular flaps.

13

Turn the figure over and position it as shown.

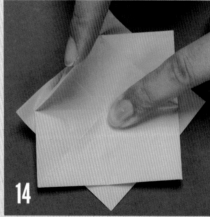

14

Locate the four corners of the square in the center of the figure. Fold each corner into the center, just as you did earlier.

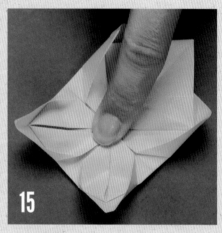

15

As you fold each side in, the flower will start to take shape.

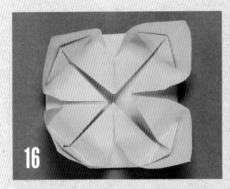

16

When all four corners are folded in, use your thumb to shape each petal. It should look like the photo when you are done.

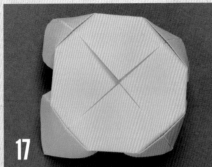

17

Turn the figure over.

18

The back of the figure will have four triangular flaps. Gently open each triangular flap and fold it toward the front of the flower.

19

The is how the completed anemone should look.

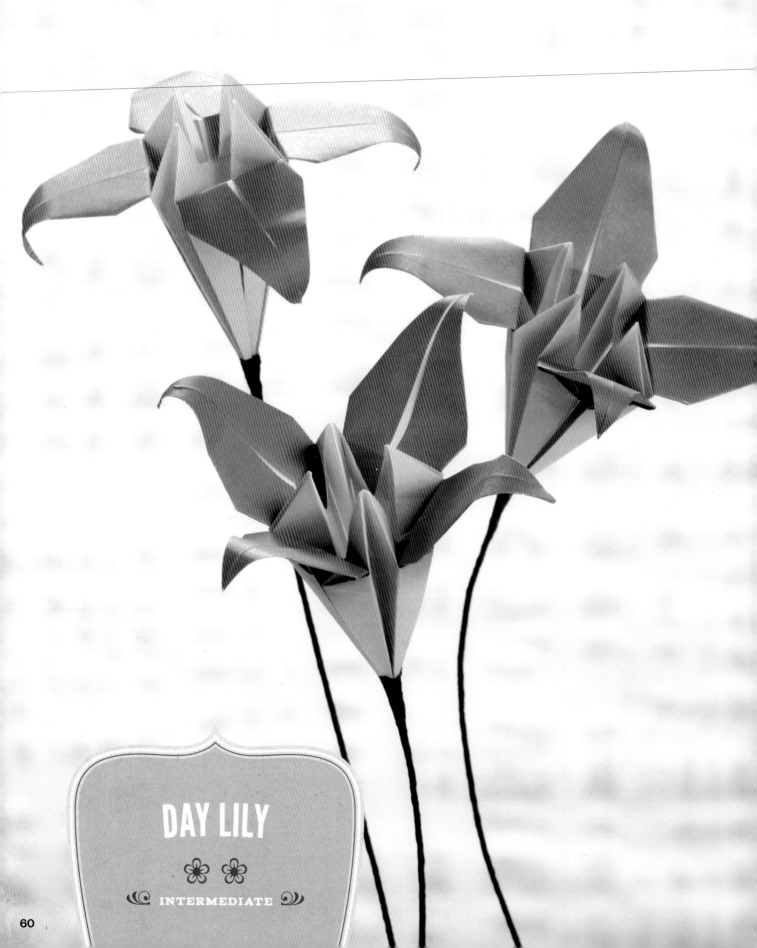

DAY LILY

❀ ❀

⦿ **INTERMEDIATE** ⦿

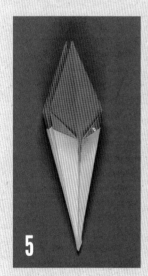

1

Make a frog base (page 20). Make sure the closed tip of the base is at the bottom and the small triangles are pointing up as shown in the photo.

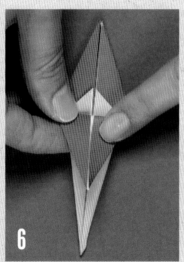

2

Arrange the base so a smooth side is facing you and on the back.

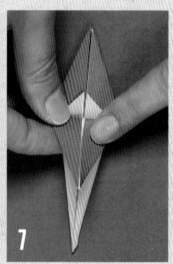

3

Fold the right side of the base in to meet the center line.

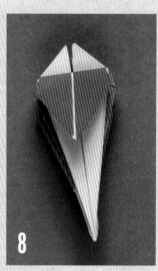

4

Repeat with the left side.

5

Repeat steps 3 and 4 for the three remaining smooth sides.

6

When you are done, the figure should look like a slimmer diamond shape. The tip of the figure should consist of four flaps.

7

Fold one flap down.

8

Then lift the flap to form a petal.

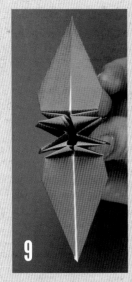

9

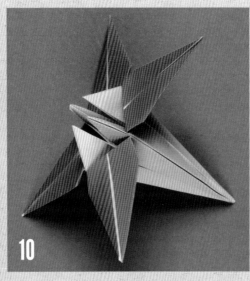

10

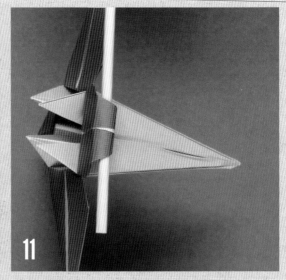

11

Continue folding and lifting all of the flaps.

When all the flaps (petals) are open, the center of the lily will also open up.

Curl each petal back with a bamboo stick.

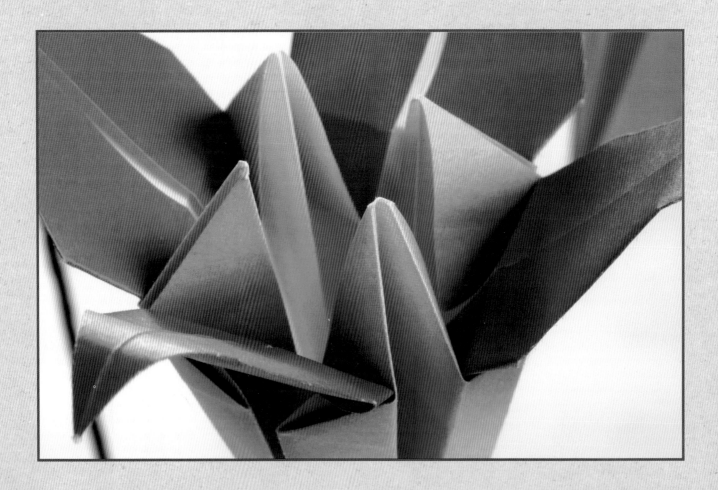

NOTE: ONE FULL HYDRANGEA FLOWER CONSISTS OF APPROXIMATELY NINE FLORETS. USE A 2-INCH-SQUARE (5.1 CM) SHEET OF PAPER FOR EACH FLORET. YOU'LL ALSO NEED FLORAL TAPE, PAPER GLUE, AND A 4-INCH (10.2 CM) LENGTH OF THIN FLORAL WIRE FOR EACH FLORET.

Start with a basic square base (page 16), colored side on the inside.

Fold the top point down about ⅓ inch (8.5 mm). Make sure the crease is really sharp.

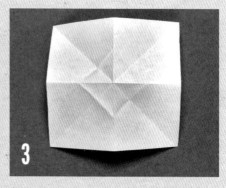

Open the paper. You should have a small diamond-shaped fold in the center of the paper.

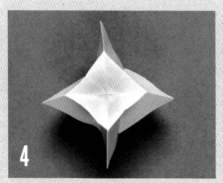

Fold the sides down as shown in the photo to isolate the diamond-shaped top of the figure.

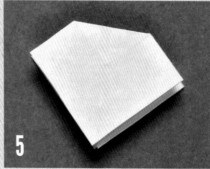

Sink fold the diamond center and completely fold down the sides to obtain the figure shown, making sure the colored side of the paper is inside.

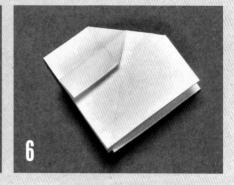

Fold the top left layer of this new figure in as shown in the photo, making sure that what was the top of the flap is perfectly aligned with the center crease.

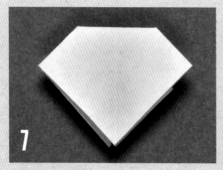

Flip the figure over.

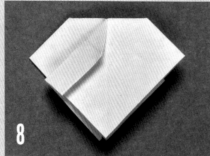

Repeat step 6 on this new side.

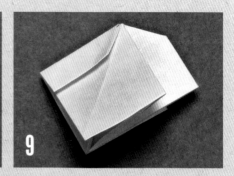

Fold the top left flap to the right, and repeat step 6.

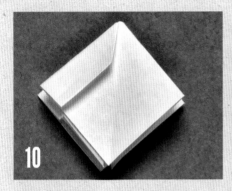

10

Flip the figure one more time, and repeat step 6.

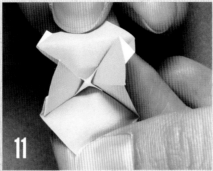

11

Gently start opening the petals.

12

While opening, push the center down with your thumb to flatten it. This is how the figure should look.

13

Turn it over to the other side. This is how the back should look with four counter-clockwise flaps.

14

Gently pull back the outer edge of one flap while opening just the end of the flap. When the end is fully open (the center's colored inside folds no longer overlap), flatten everything back with a sharp crease.

15

Repeat for the remaining three flaps.

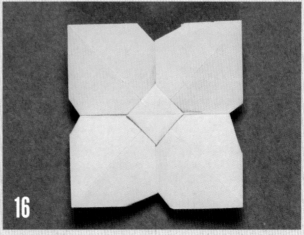

16

This is how the floret should look when turned over.

Wrap the top few inches of one piece of the floral wire with the floral tape.

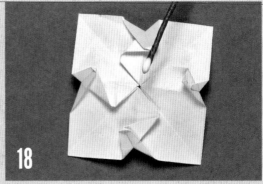

Apply a drop of paper glue to the wrapped end of the wire.

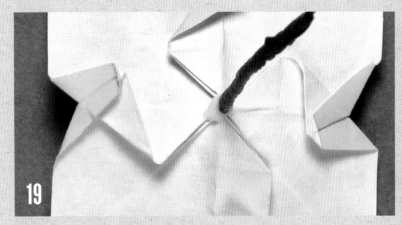

Secure the wire in the hole at the center of the floret's back. Allow the glue to dry.

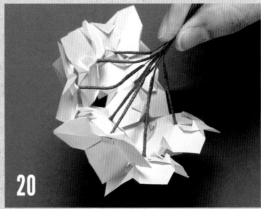

Repeats steps 1 through 19 to make about eight more florets. Gather them together by their stems.

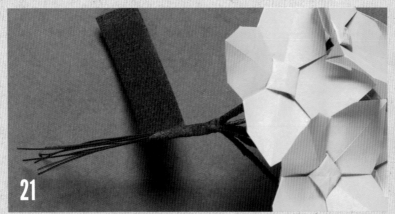

Wrap the stems securely with floral wire.

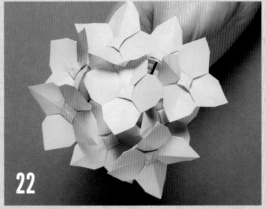

This is how the hydrangea will look from the top.

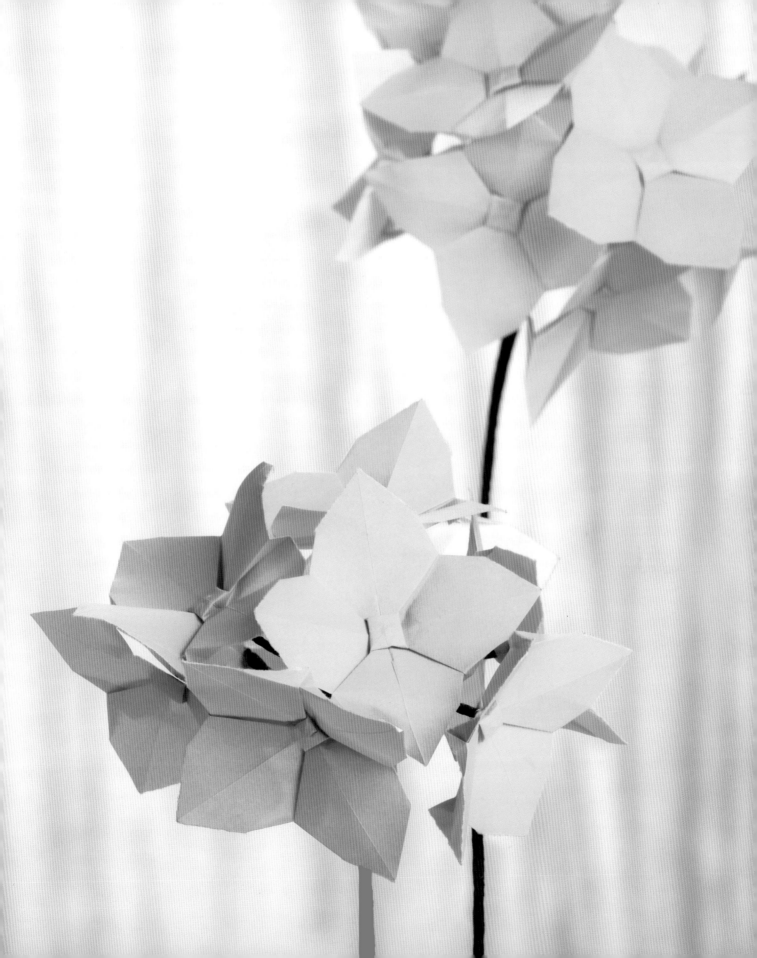

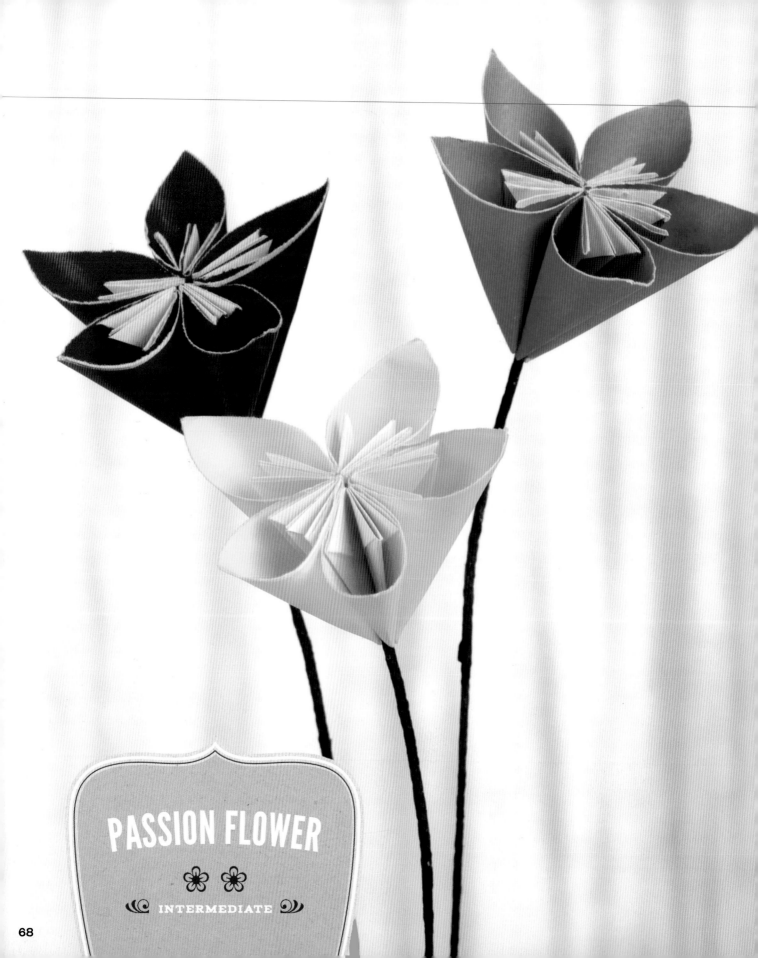

PASSION FLOWER

✿ ✿

INTERMEDIATE

HOW YOU FOLD IT

NOTE: YOU MAY USE EITHER 6-INCH (15.2 CM) OR 2-INCH (5.1 CM) SHEETS OF ORIGAMI PAPER FOR THIS PROJECT, DEPENDING ON HOW LARGE YOU'D LIKE THE COMPLETED FLOWER TO BE. YOU WILL NEED FIVE SHEETS OF PAPER (ONE FOR EACH PETAL).

Start with one sheet of paper colored side down.

Make a valley fold through the middle to divide the square into two triangles.

Fold the figure in two, but do not crease it completely. Just pinch the paper to mark the middle of the triangle. Fold the left side of the triangle down as shown in the photo.

Fold the right side of the triangle down as shown in the photo.

Lift up the left flap.

Open the flap.

Push the flap down flat with a squash fold (page 14), making sure the center lines overlap.

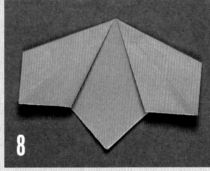

Repeat steps 5 through 7 for the right flap.

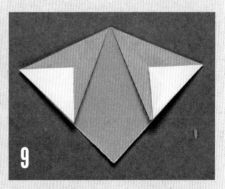

When you're done, you should have three diamond shapes. Fold the tips of the two outer triangular shapes up in a mountain fold.

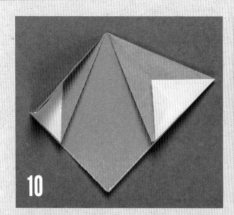

10

Fold the left outer triangle in half with a valley fold.

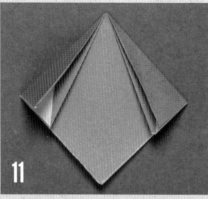

11

Repeat on the right side. This is how the figure should look.

12

Spread glue on the left side.

13

Press the two sides together.

14

This is how the completed petal should look.

15

Use a bamboo stick to curl back the tip of the petal.

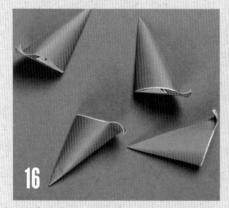

16

Repeat steps 1 through 15 to make four more petals.

17

Add glue to the seam on each petal.

18

Gather the petals together at their glued seams to create a flower.

Add a floral wire stem.

Attach the rest of
the petals.

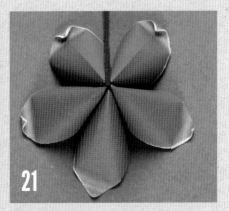

Here is the bottom of the flower
with the stem attached.

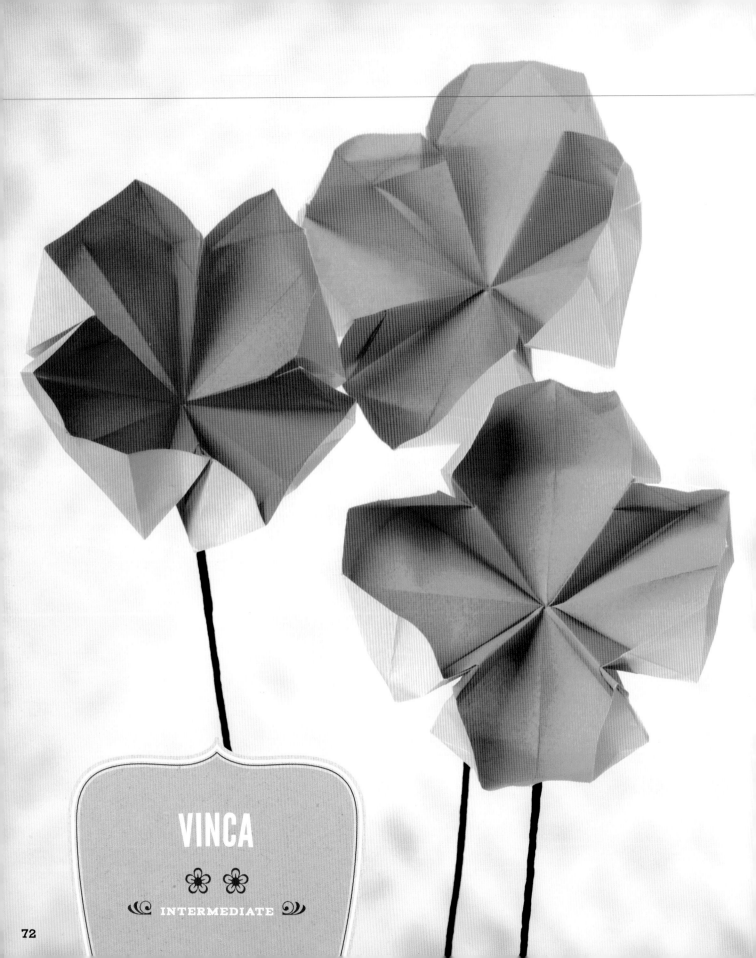

VINCA

❀ ❀

◖◖ INTERMEDIATE ◗◗

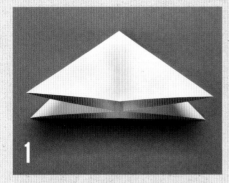

1

Start with a waterbomb base (page 18) with the colored side of the paper on the inside.

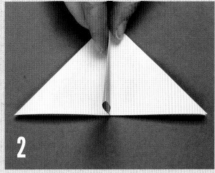

2

Lift one flap.

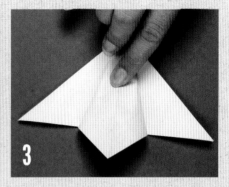

3

Open the flap and then flatten it down.

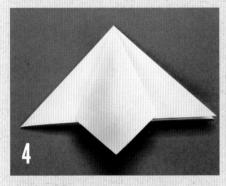

4

Make sure its center crease aligns with the center of the figure.

5

Repeat steps 2 through 4 for all sides. When finished, the figure should be a diamond shape.

6

Lift up and fold back the small triangle at the bottom of the diamond.

7

Lift up and fold back all the remaining small triangles. This is how the figure should look.

8

Lift the left base of the figure to align it with the center crease and fold it.

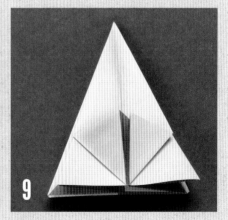

9

Repeat on the right side.

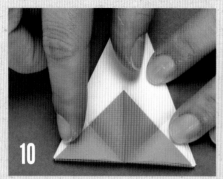

10

Reopen the folds you just made.

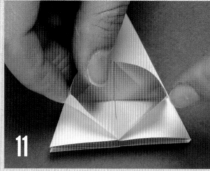

11

Open the figure's bottom flap by lifting the middle as shown.

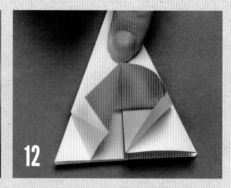

12

You'll see two triangles of color. Align these triangles in the middle as you inner fold the white bases.

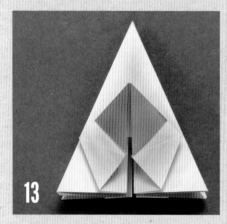

13

Smooth the paper down once the colored triangles are aligned in the middle (this is a bit tricky, so use the photo for reference—this is how the figure should look when the first side is complete).

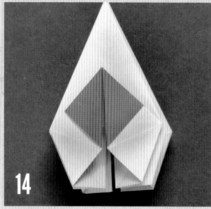

14

Repeat steps 8 through 13 for all remaining sides. This is how the figure should look when you've completed the steps for all sides.

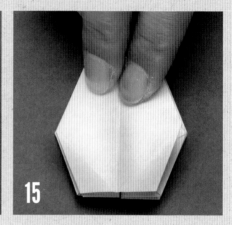

15

Fold one flap over so that you have a smooth section facing you.

16

Fold the entire shape in half on the vertical crease.

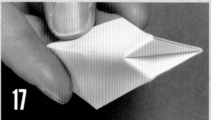

17

At a point about one-third of the length from the tip of the figure, make an inner reverse fold.

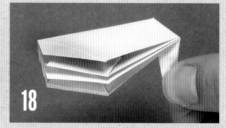

18

This will create the stem of the flower. Hold the flower by this stem.

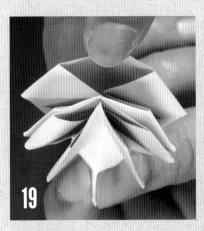

19

Slowly open it.

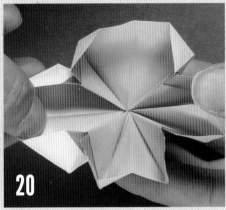

20

This is how the figure should look as you open the petals.

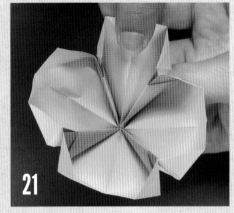

21

Fully open each petal by pushing down the center crease.

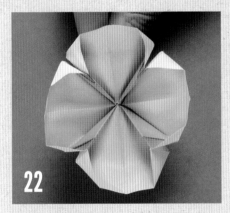

22

This is how the completed flower should look from the front.

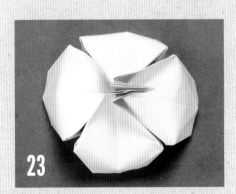

23

This is how the completed flower should look from the back.

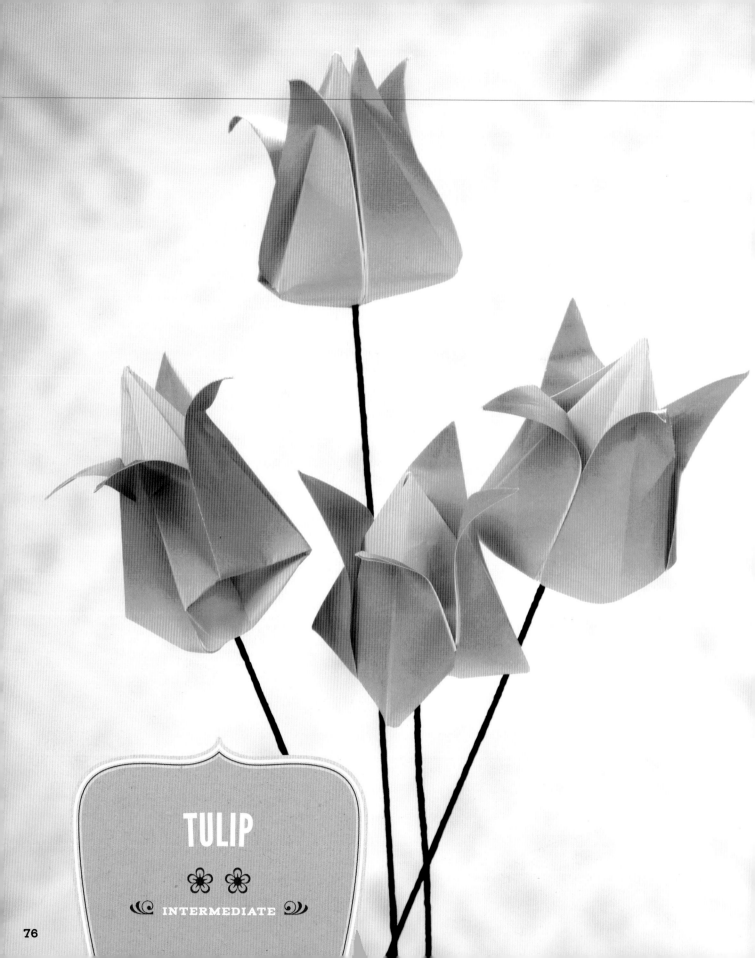

TULIP

❀ ❀

INTERMEDIATE

NOTE: THE FLOWER SHOWN WAS MADE WITH GRADIENT-COLOR PAPER.

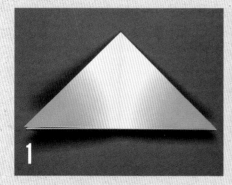

1 Start with a waterbomb base (see page 18).

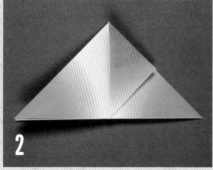

2 Fold the right bottom tip of the triangle to the center line using a valley fold.

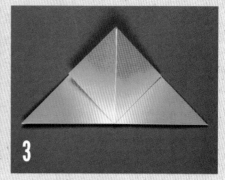

3 Repeat for left side.

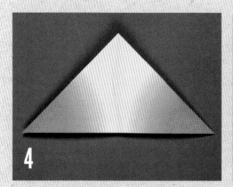

4 Flip the figure over.

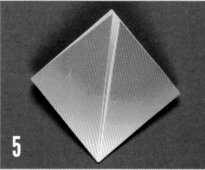

5 Repeat steps 2 and 3 on this side to create a diamond shape with two triangles on each side.

6 Fold the right flap of the diamond shape to the left. Flip the figure over and repeat on the other side. You now have a figure with smooth diamond shapes on each side.

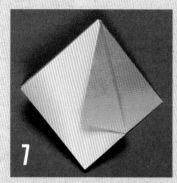

7 Fold one of the lateral tips toward the center line, making sure that it overlaps the center line by about 1/8 inch (3 mm).

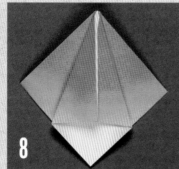

8 Do the same for the opposite side. The two folds should overlap in the center.

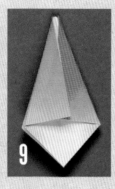

9 Turn the paper over and repeat the folds on this side.

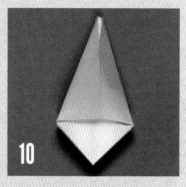

10 When you're done, tuck the overlapping corners into each other on both sides of the figure.

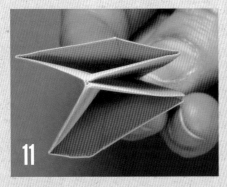

11 Look at the bottom of the figure. You should see a small hole through which you will inflate the figure.

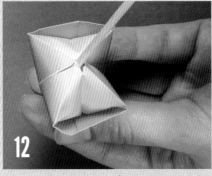

12 Either blow air (slowly) into the hole to inflate the figure or use a thin stick to open it up.

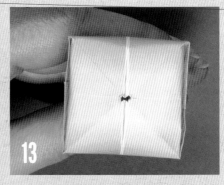

13 The result should be a three-dimensional shape. This photo shows it from the bottom.

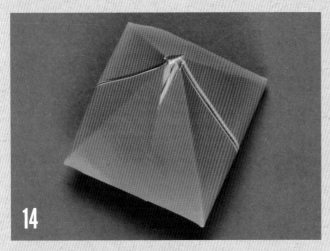

14 Each corner of the shape is covered in a layer of paper.

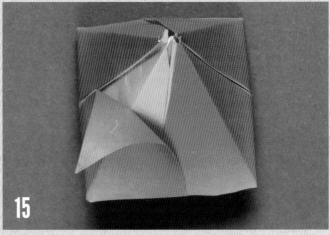

15 Gently peel each layer away from the midsection.

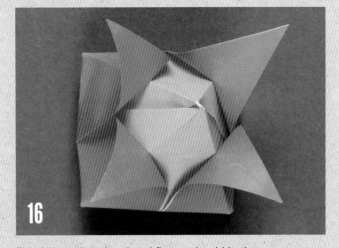

16 This is how the completed flower should look.

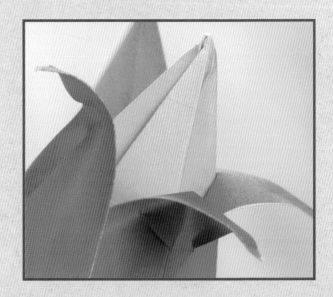

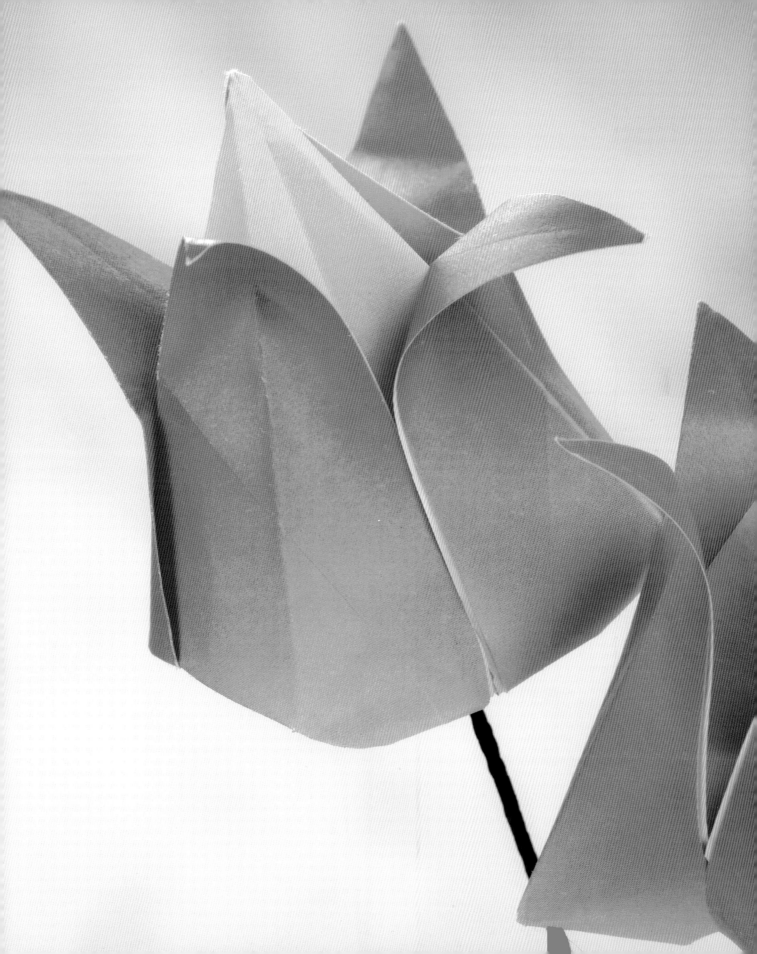

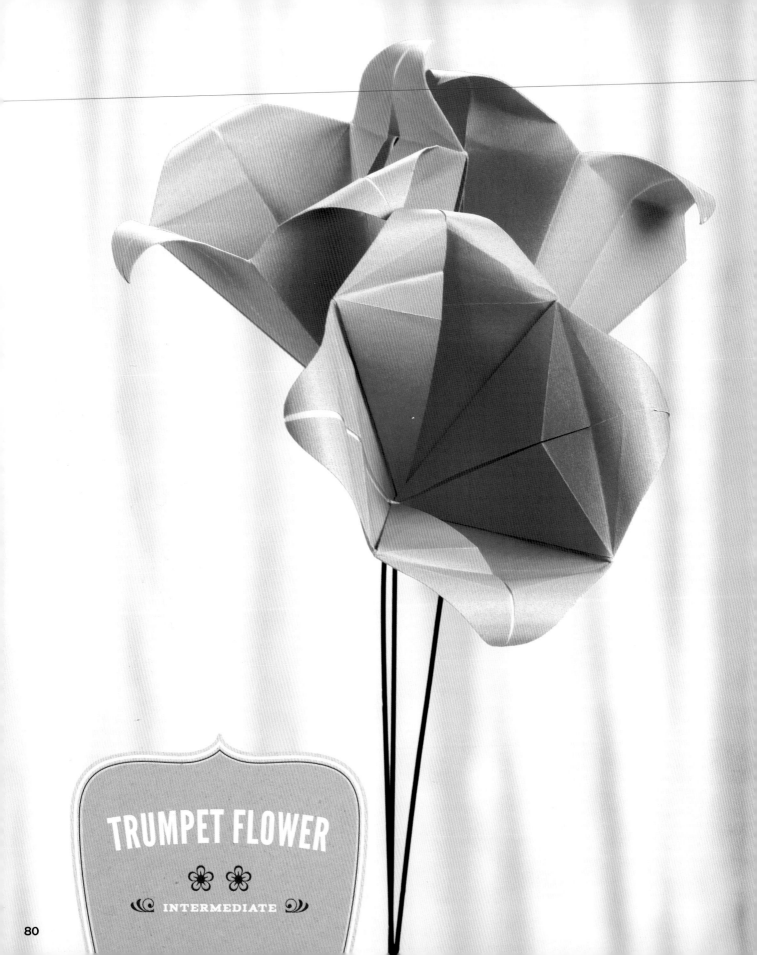

TRUMPET FLOWER

❀ ❀

INTERMEDIATE

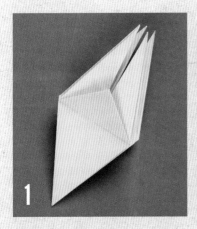

Start with a frog base (page 20).

Open the frog base slightly to reveal four tall and four short triangles.

Hold two of the smaller triangles to isolate the taller triangle in between them.

Still holding onto the two smaller triangles, carefully fold the taller triangle into the center of the figure, making sure it doesn't unfold as you do so.

Repeat for the remaining three taller triangles.

6

7

As you fold the taller triangles inside, the four smaller triangles become the petals of the flower.

Use a bamboo stick to curl the petals back.

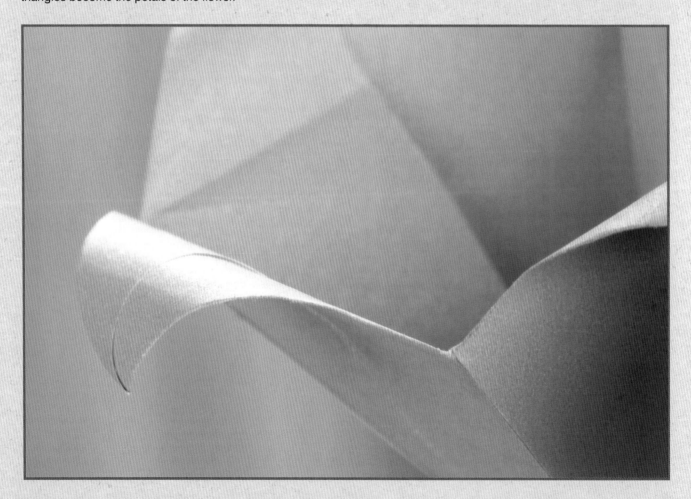

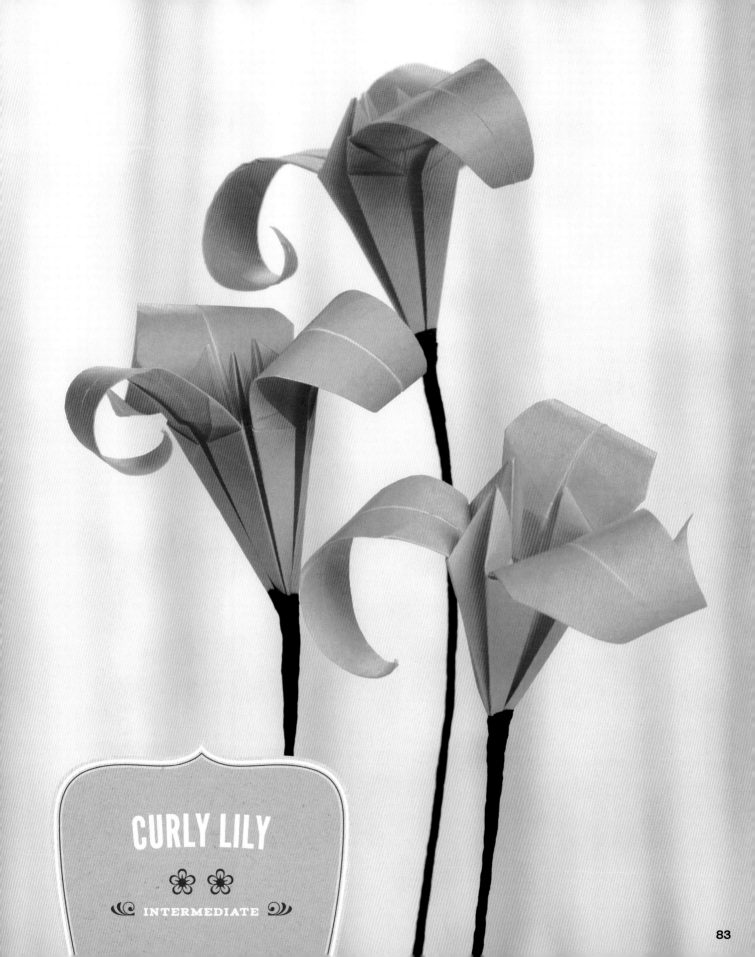

CURLY LILY

❀ ❀

≪ɕ INTERMEDIATE ɝ≫

1 Start with a triangular sheet of paper (page 23), colored side down.

2 Fold the triangle in the middle by overlapping opposite corners. Repeat the fold for all three corners. This is how the creases should look when you are finished.

3 Collapse the paper into a rhombus shape. (It should be one-flap thick on the left side and two-flaps thick on right side).

4 Lift up the top right-side flap.

5 Flatten the flap with a squash fold (page 14), making sure the center lines overlap.

6 Repeat steps 4 and 5 on the remaining two sides.

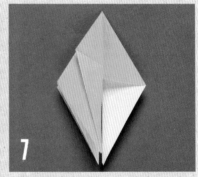

7 To begin a petal fold (page 15), diagonally fold the left lateral flap so it aligns with the center line, and make a sharp crease.

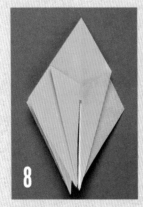

8 Repeat the crease for right flap.

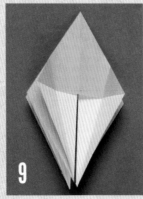

9 Now open the folds you just creased.

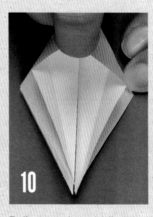

10 Pull up on the middle.

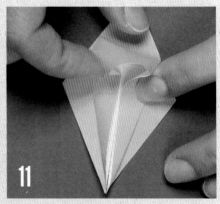

11 Close the lateral flaps in completely until they align in the middle.

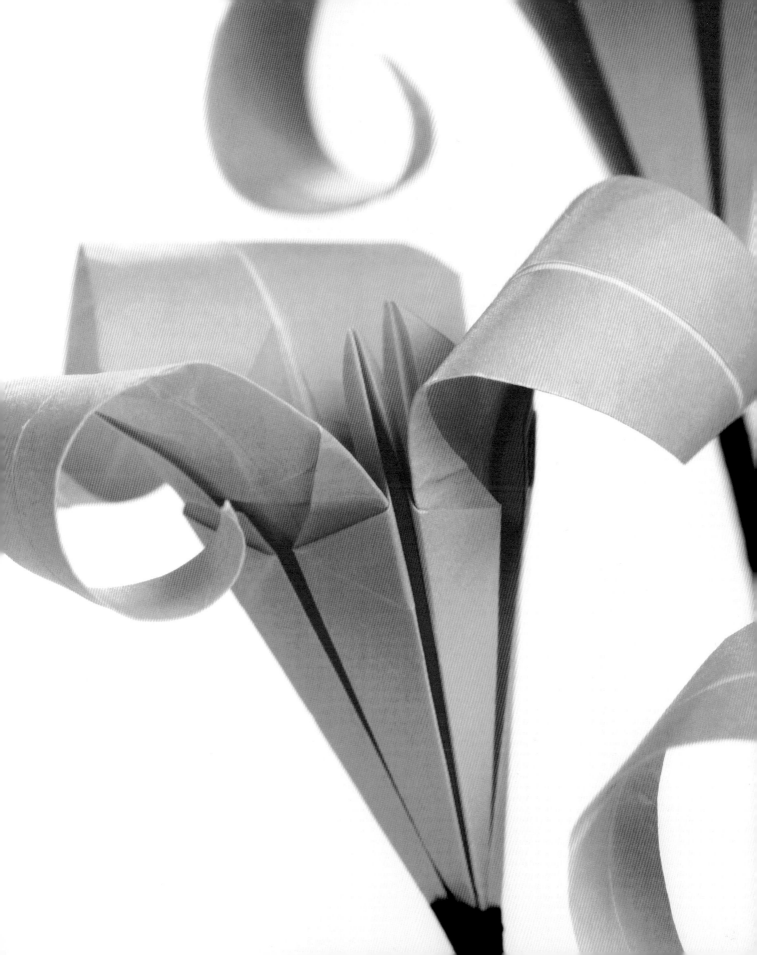

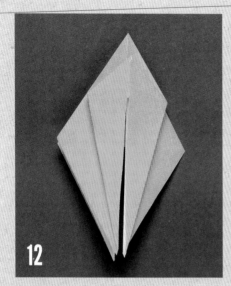

12

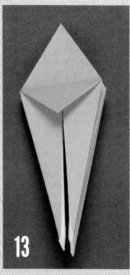

13

14

15

This should create a small triangle at the tip where the two sides meet. Make sure the small triangle is pointing up toward the tip at the top of the figure. Repeat steps 7 through 12 with the remaining two flaps.

Fold all of the small triangles down.

Refold the figure so a smooth side is facing you.

Diagonally fold the top right side to align with the center crease.

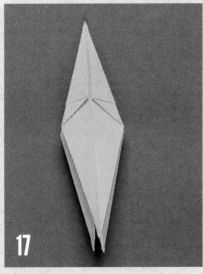

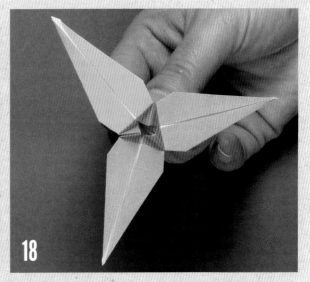

16 Repeat on the top left side.

17 Repeat with the other two flaps. You should now have a narrow diamond-shaped figure.

18 Open the flower by gently pulling down one petal at a time.

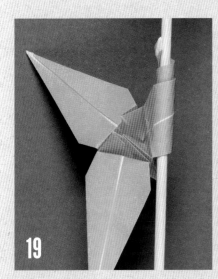

19 Use a bamboo stick to curl each petal backwards.

20 This is how the completed flower should look.

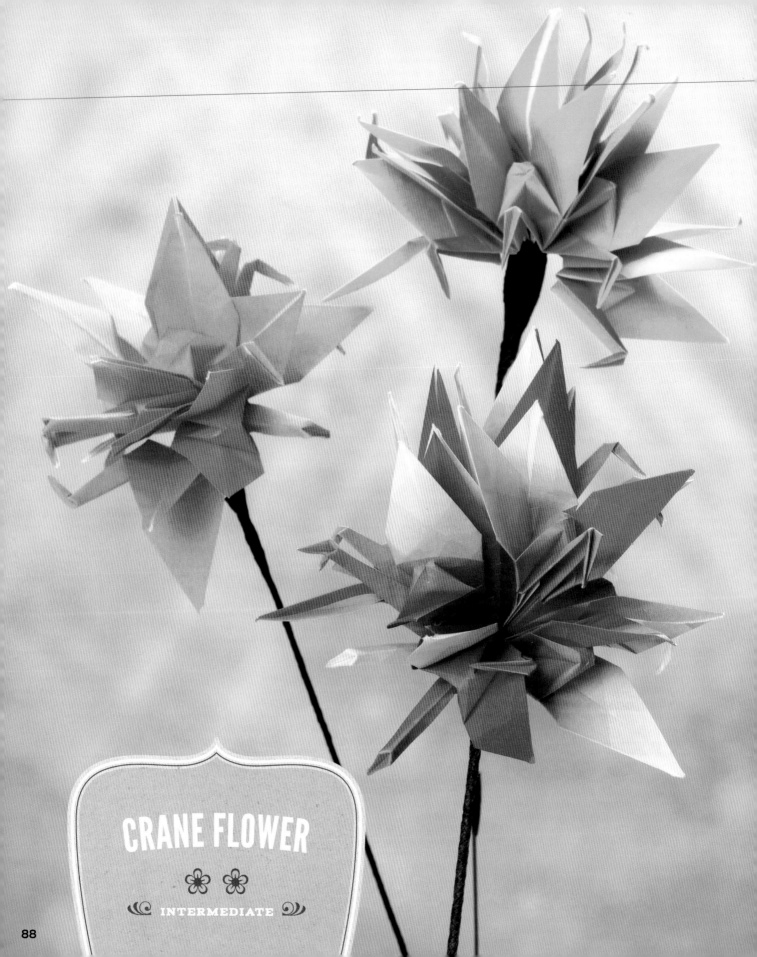

CRANE FLOWER

❀ ❀

❧ INTERMEDIATE ❧

NOTE: YOU WILL NEED THREE 6-INCH (15.2 CM) SHEETS OF ORIGAMI PAPER TO MAKE THIS FLOWER. CUT EACH SHEET INTO FOUR SMALLER SQUARES FOR A TOTAL OF 12. YOU WILL ALSO NEED ONE WIRE STEM AND FLORAL TAPE.

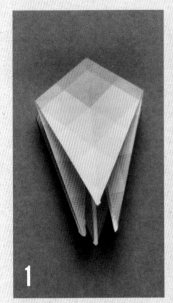

1

Start by making a bird base (page 22).

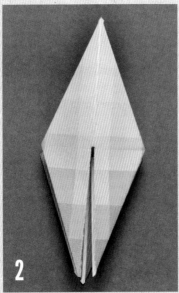

2

Lift the bottom tip of the top layer all the way up. This is how the figure should look once the top layer is lifted up

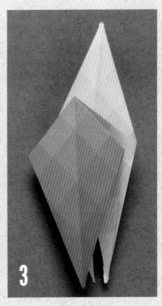

3

Flip the figure over.

4

Repeat step 2.

5

Diagonally fold the left side into the middle as shown.

6

Repeat on the right side.

7

Flip the figure over and repeat steps 5 and 6 on the other side.

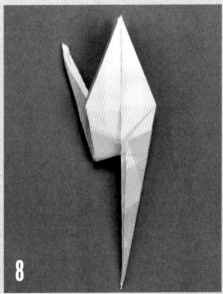

8

Make an inside reverse fold (page 14). To get started, fold the bottom left tip of the structure up. Crease well. Flip it over and repeat the same crease on other side.

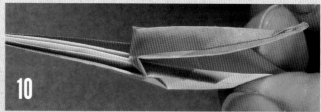

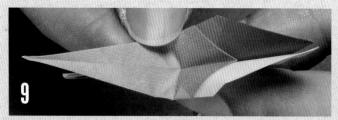

The tip you just creased consists of a top and a bottom layer. Open the section up so you are looking at the smooth surface between the layers—it should look like the photo.

Push up on the tip and use the crease you made in step 8 to fold the section in on itself.

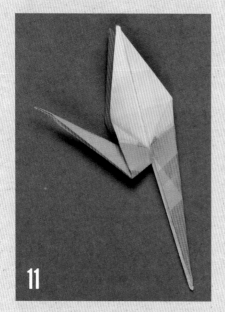

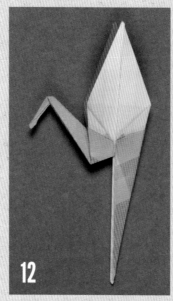

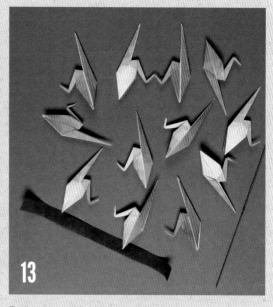

The section will point up at an angle. This is the neck of the crane.

Make an inner reversed crease (page 14) at the top of the neck. This is the beak of the crane.

Repeat steps 1 through 12 to make 11 more cranes.

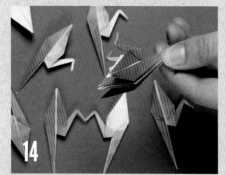

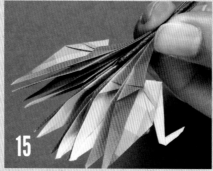

Gather all the cranes into a bunch, holding each by its straight leg.

Arrange the cranes into a pleasing shape, and insert the floral wire at the point where the legs meet.

Secure everything as tightly as possible with the floral tape.

17

When you're done, "fluff" the cranes to shape the flower. You can open some of the cranes to give the flower more volume by pulling the wings sideways while pushing down on the center.

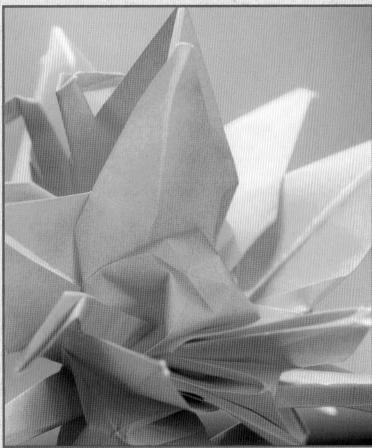

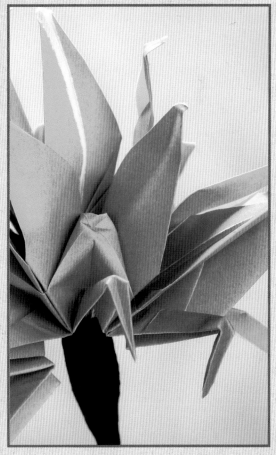

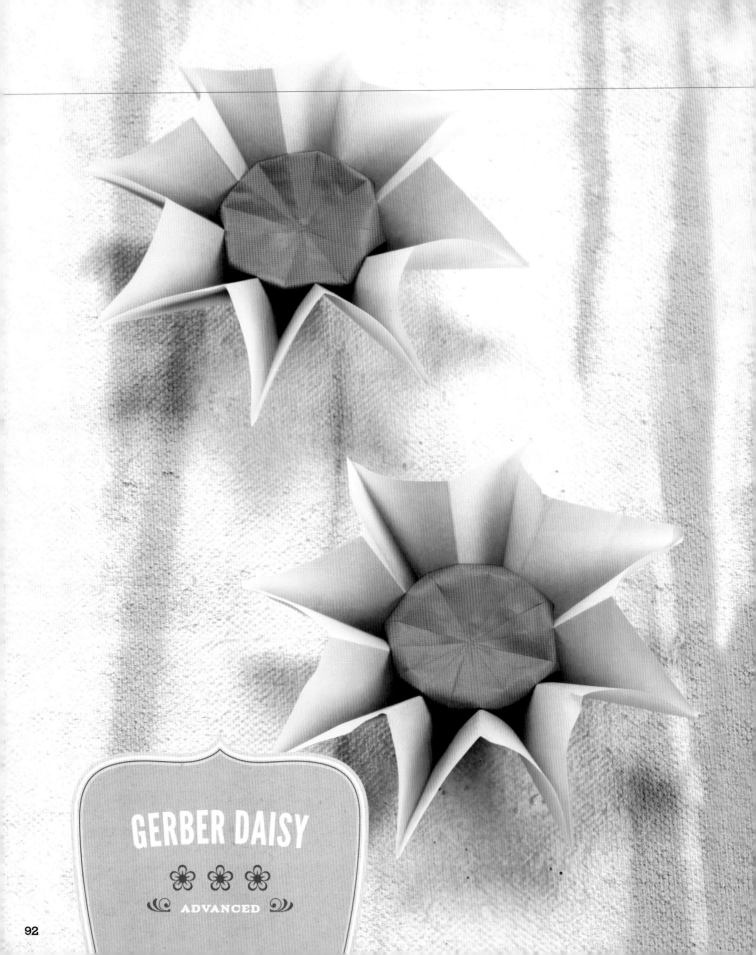

GERBER DAISY

✿ ✿ ✿

ADVANCED

NOTE: THIS FLOWER LOOKS BEST WHEN MADE FROM ORIGAMI PAPER WITH A GRADIENT CIRCLE OF COLOR IN THE CENTER AND ANOTHER COLOR ON THE EDGES (SEE PAGE 10). IF YOU CAN'T FIND THIS PAPER, COLOR PLAIN ORIGAMI PAPER WITH MARKERS.

1

Follow the instructions on page 26 to make an octagon, making sure the colored side of the paper is inside when you get to the part where you make a square base.

2

Collapse the paper back along the fold lines as shown.

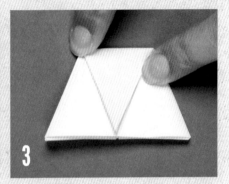

3

Fold the top tip down to meet the bottom center of the triangle. Crease well.

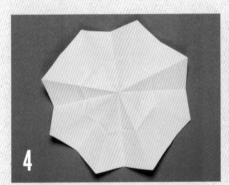

4

Open up the paper.

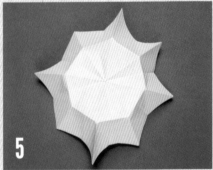

5

Sink fold (page 15) the center of the octagon.

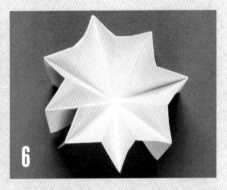

6

Gather the new folds together, four on each side.

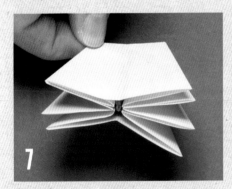

7

This is how the figure should look when the folds are complete.

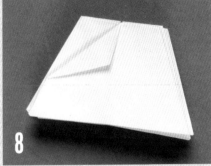

8

Fold one upper corner diagonally so that the side aligns with the center.

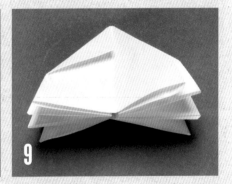

9

Repeat for all eight sides.

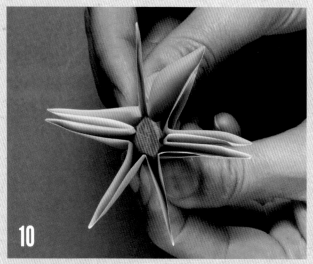

10

Slowly open the flower.

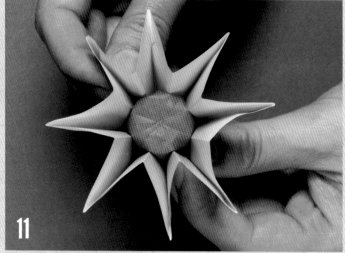

11

Push the center gently down with your thumb to shape it as you use your fingers to pull the petals open.

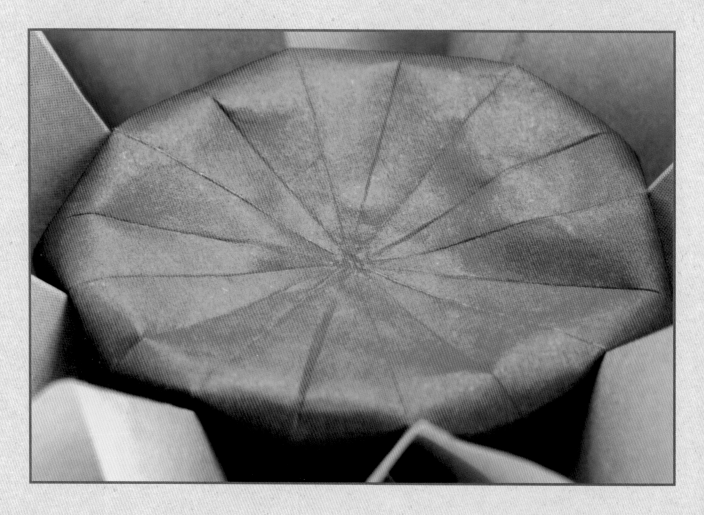

HOLLYHOCK

✿ ✿ ✿

ADVANCED

1

Start with paper colored side down.

2

Make a horizontal valley fold though the middle to divide it into two rectangles.

3

Now do the same for both of the rectangles.

4

When you're done, the paper should be divided into four slim rectangles.

5

Turn the paper 90 degrees and repeat steps 2 and 3.

6

When you're finished, the paper should be divided into 16 squares.

7

Turn the paper colored side up.

8

Fold the paper in half diagonally as shown in the photo.

9

Open the paper and then fold it so the top right corner of the paper meets the top right corner of the bottom left square.

10

Open it and fold it again so the top right corner meets the top right corner of the next diagonal square (the center of the paper).

11

And then the top right corner of the next diagonal square.

12

Turn the paper 90 degrees and repeat steps 8 through 11. This is how the paper should look when you are done.

13

Fold each of the four corners to the center as shown.

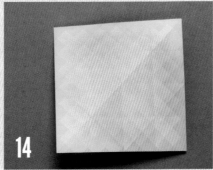

14

Turn the paper over.

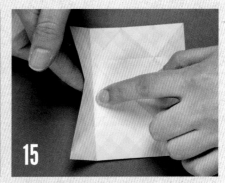

15

Lift the center of one edge until the first vertical crease.

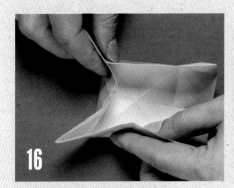

16

Repeat step 15 with the other three edges.

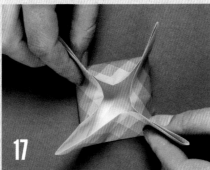

17

Now you should have four pockets.

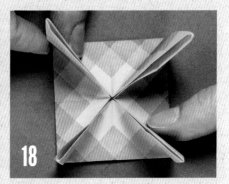

18

When you're done, flatten down the triangle centers between the pockets.

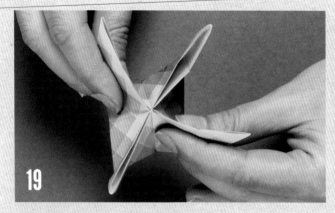

19

Now lift the figure and fold down the base.

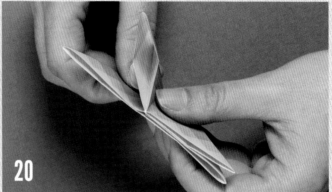

20

Continue folding until the entire figure is collapsed.

21

This is how the figure should look when collapsed.

22

Crease the top of each side of the figure, starting at one tip and folding down.

23

Continue folding until you reach the other tip.

24

This is how the figure should look when all the sides are creased.

25

Carefully open each petal by inserting your thumb into the petal.

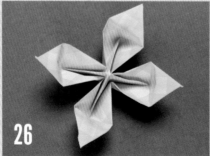

26

This is how the top of the completed flower should look.

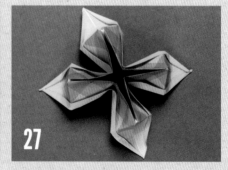

27

This is how the back of the completed flower should look.

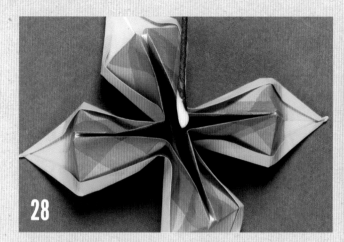

28

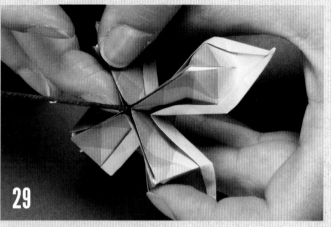

29

Add a drop of paper glue to one floral wire stem. Insert the glued end into the center of the back of the flower.

Press the sections of the back together to secure the floral wire and let it dry completely.

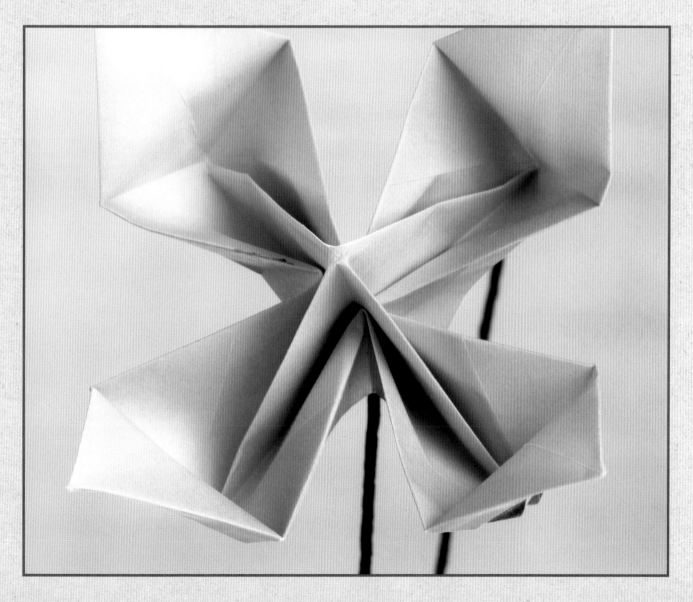

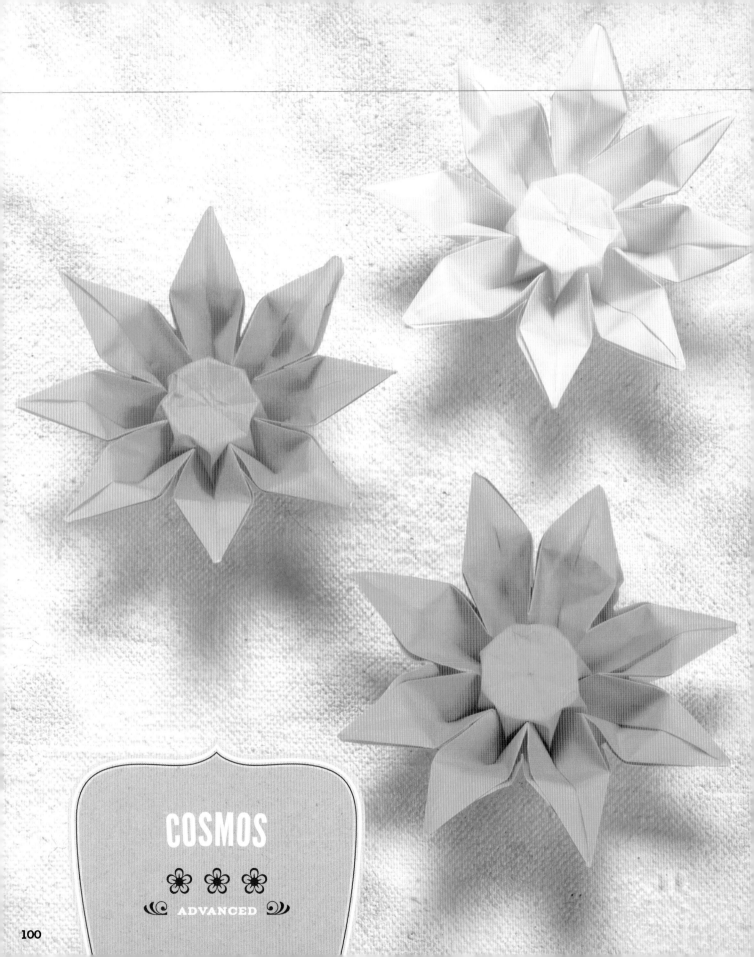

COSMOS

❀ ❀ ❀

ADVANCED

NOTE: THIS FLOWER LOOKS BEST WHEN MADE FROM ORIGAMI PAPER WITH A GRADIENT CIRCLE OF COLOR IN THE CENTER AND ANOTHER COLOR ON THE EDGES (SEE PAGE 10). IF YOU CAN'T FIND THIS PAPER, COLOR PLAIN ORIGAMI PAPER WITH MARKERS.

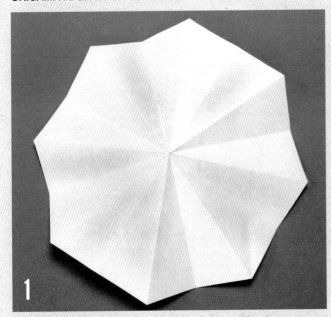

1

Follow the instructions on page 26 to make an octagon, but make sure the colored side of the paper is on the inside of the square base. Place the octagon color side down. Notice that the octagon has eight edges and each edge has a center crease.

2

Fold the two sides of each edge so that each line overlaps the crease that divides the center of each edge.

3

Fold the new crease only until you meet the crease that divides the center of each edge.

4

This is how the octagon will look when you've made all the creases.

5

6

As you can see in the photo, the creases have made a small triangle at each of the octagon's eight edges. Now repeat the same creases as in steps 2 and 3, this time dividing those small triangles you just created.

This is how the octagon should look when you've completed this second set of creases for all eight sides.

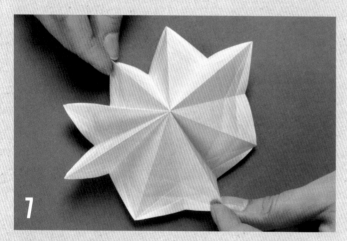

7

Collapse the paper back along the fold lines as shown.

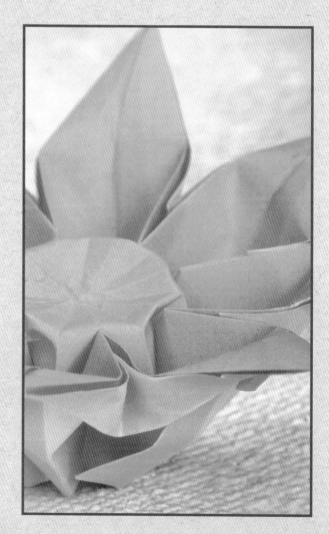

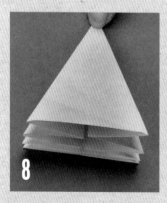

8

This will create a triangle.

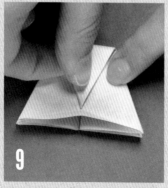

9

Fold the top tip down to meet the center of the small bottom triangle. Be sure to crease well.

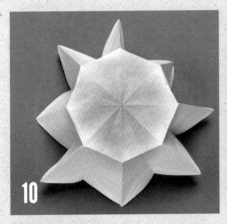

10

Open the octagon as shown. There should now be a smaller octagonal crease in the center of the octagon.

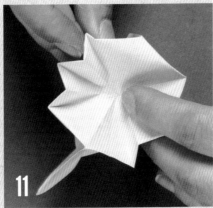

11

Use the creases to sink fold (page 15) this smaller octagon.

12

Gather the new folds together, four on each side.

13

This is how the figure should look when the folds are complete. Place the figure on a flat surface with the longer end (the open ends) on top.

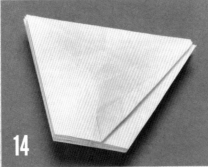

14

Valley fold the bottom right corner flap in so that it meets the center line.

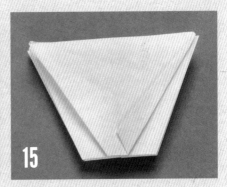

15

Mountain fold the bottom left corner flap in so it meets the center line.

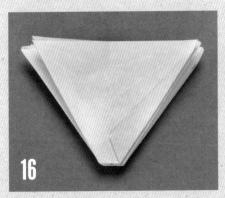

16

Repeat steps 14 and 15 for all sides.

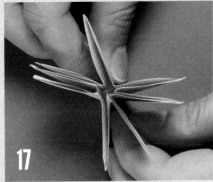

17

Open the flaps (petals) slightly.

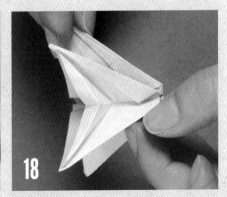

18

You'll work next on the space between each flap/petal. As you can see in the photo, the folds you made in steps 3 through 5 created inner and outer arrow-shaped creases on each edge.

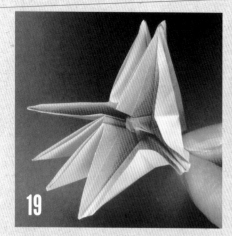

19

Working one space between petals at a time, use the outer arrow-shaped crease to valley fold the paper in, and then use the inner arrow-shaped crease to mountain fold the paper backwards. This will form the sides of two adjoining petals.

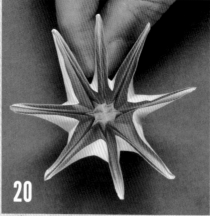

20

When you're done, you'll have eight skinny petals.

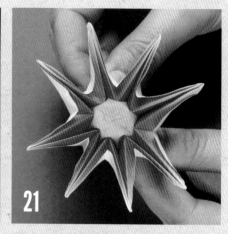

21

Open the petals slightly and gently flatten the center of the flower.

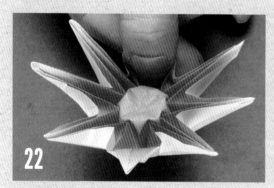

22

Insert your thumb in the middle of each petal to open it.

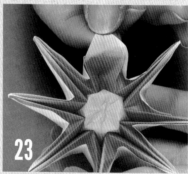

23

Then fold the tip of each flower back a bit.

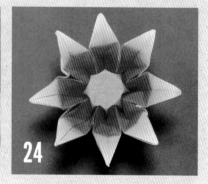

24

This is how the completed cosmos should look from the front.

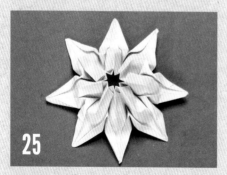

25

This is how the completed cosmos should look from the back.

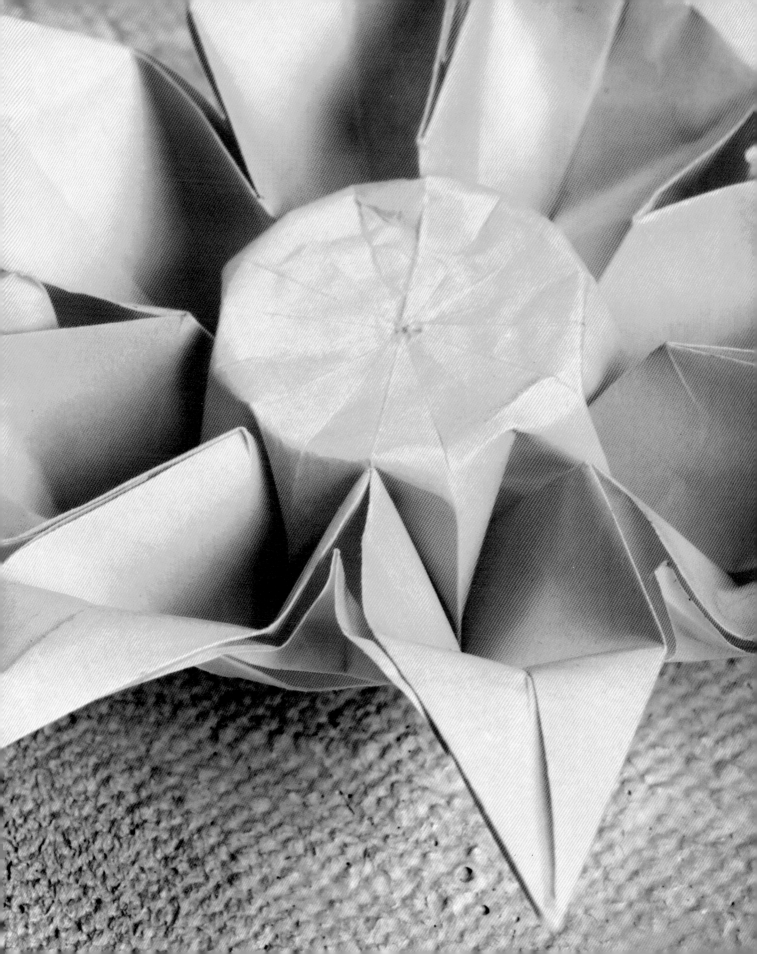

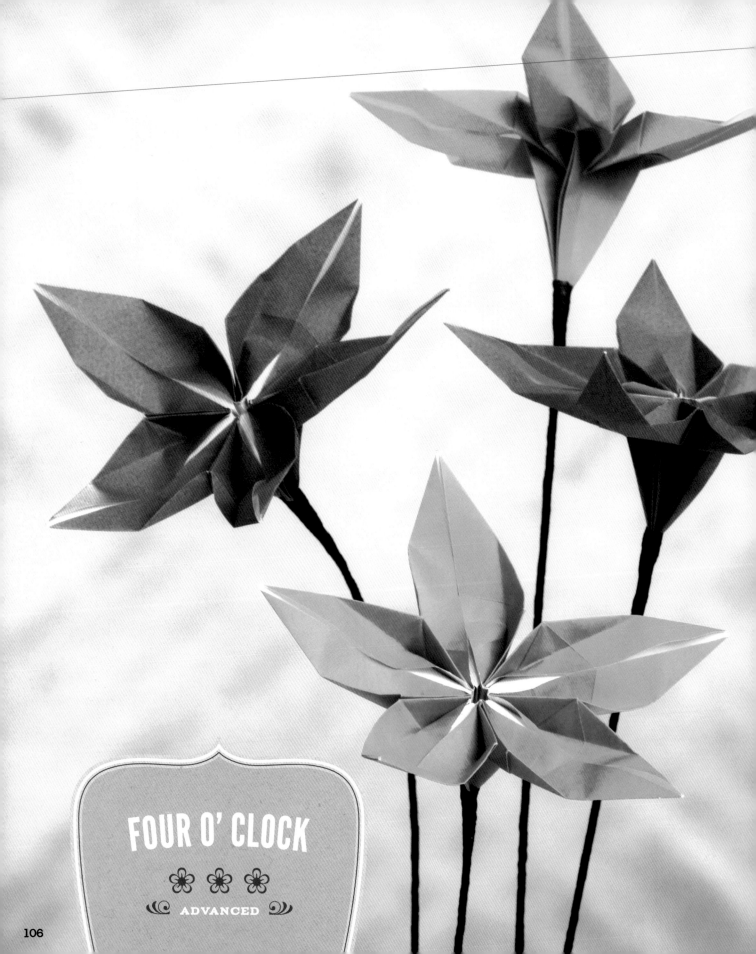

FOUR O' CLOCK

❀ ❀ ❀

ADVANCED

1

Follow the steps on page 24 to make a pentagon.

2

Fold the pentagon into a diamond shape by collapsing it as shown in the photo.

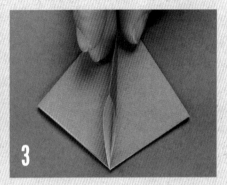

3

Lift one flap.

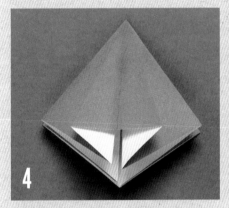

4

Open the flap and then flatten it down with a squash fold (page 14), making sure its center crease aligns with the center of the figure.

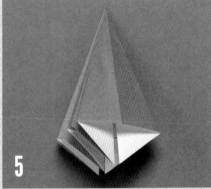

5

Repeat with all sides. When you are done, the figure should look like the slimmer diamond shape shown in the photo.

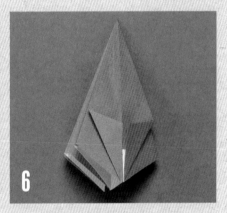

6

To make a petal fold (page 15), diagonally fold the bottom sides of the diamond so that they meet at the centerline as shown in the photo.

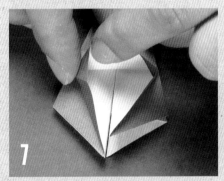

7

Open the folds you just created. Open the figure by pulling up on the middle.

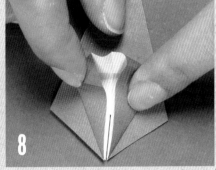

8

Close the lateral flaps in completely until they align in the middle.

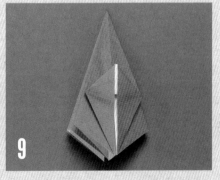

9

This should create a small triangle at the tip where the two sides meet.

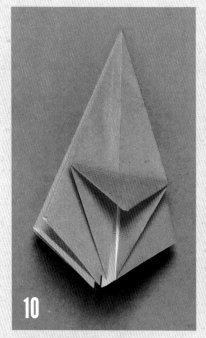

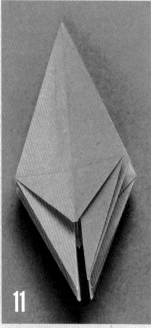

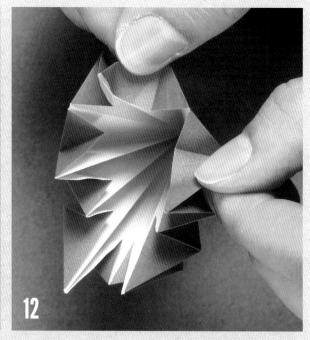

10 Fold down this tip.

11 Repeat steps 6 through 10 to petal fold all remaining sides.

12 When you're done, open the figure partly by pulling on the two top base tips. The top of the figure should have taller and smaller tips. The smaller tips will be folded in to the center of the figure on their precreased lines.

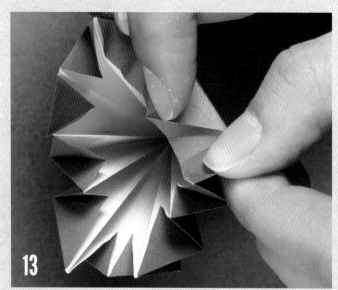

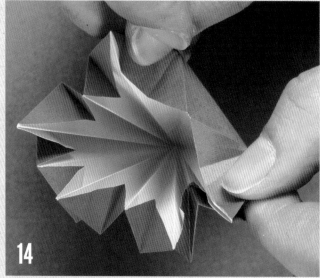

13 To fold in the first small tip, lift the center of the smaller tip between the base triangles to unfold it.

14 Refold it in on itself.

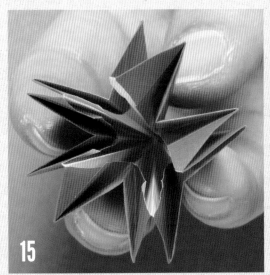

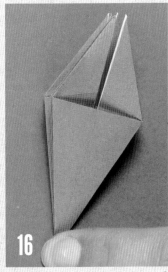

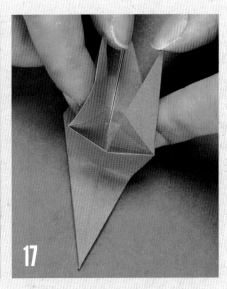

15 Keep folding until it tucks in between the two base triangles.

16 Repeat for all sides. Position the figure so the closed point is at the bottom and the tips are at the top.

17 Hold the two top tips.

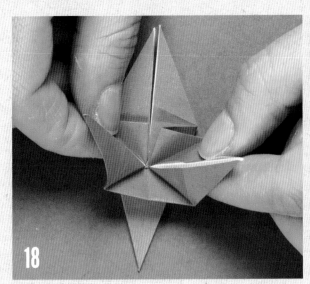

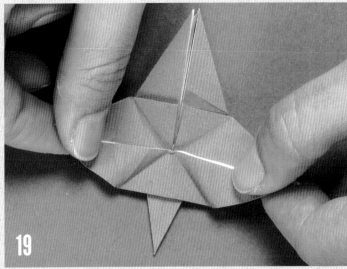

18 Gently pull the tips apart.

19 Flatten the tips down on both sides.

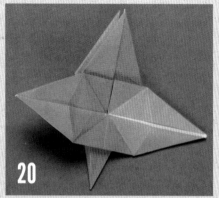

20

Here is how the figure should look with the tips flattened.

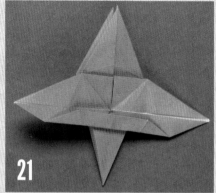

21

The flattened tips form a rhombus shape. Valley fold the lower part of the rhombus to the centerline.

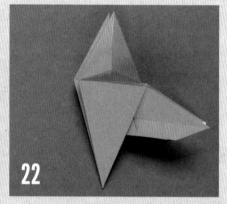

22

Now fold the left bottom portion of the figure over the right bottom portion. It should look like the photo.

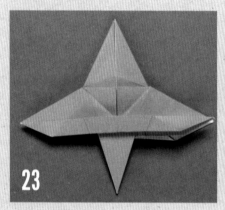

23

Repeat step 17 though 22 for the rest of the tips.

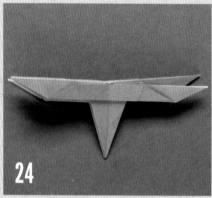

24

This is how the paper should look when you have finished folding all five flaps.

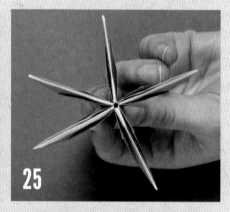

25

Hold the figure by the bottom tip and gently separate each flap/petal.

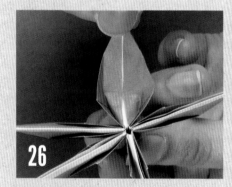

26

Each petal has an opening in the middle. Insert your thumb and completely open one petal.

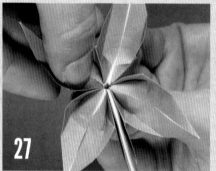

27

Repeat for the other four petals. As you open each flap, gently arrange the petals to shape the flower.

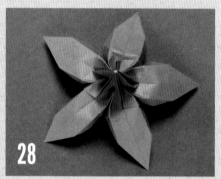

28

This is how the back of the completed four o'clock should look.

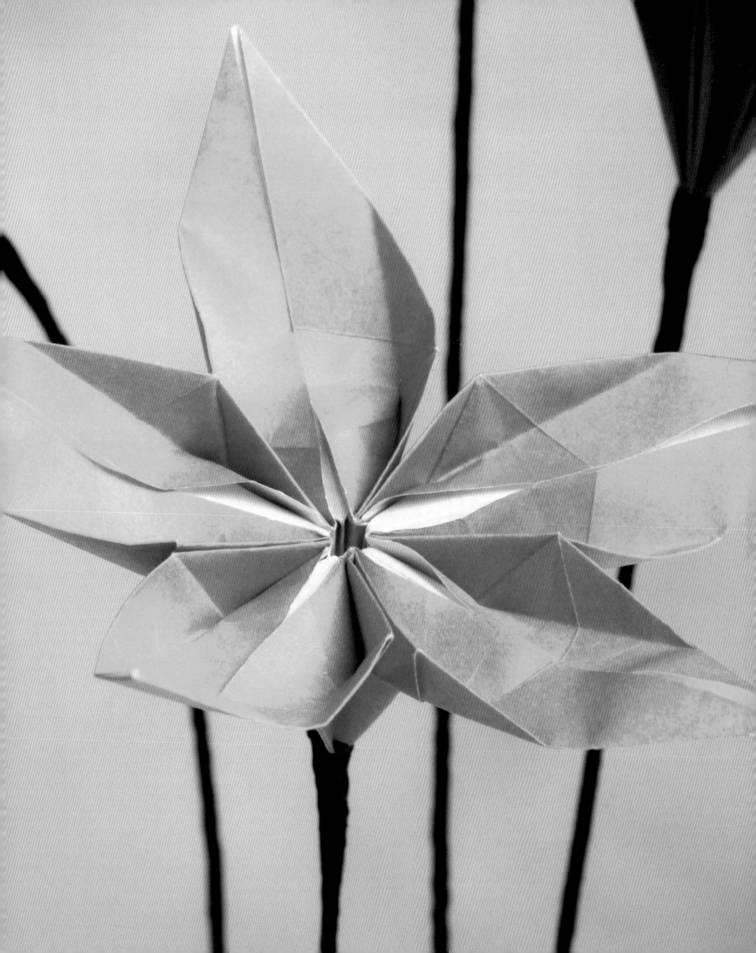

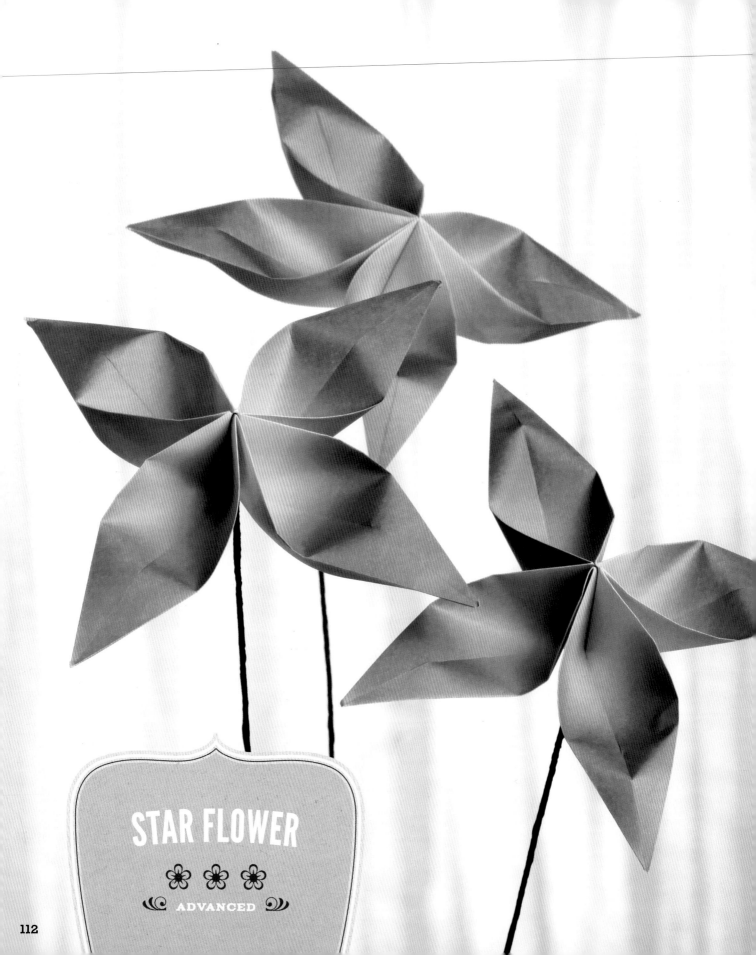

STAR FLOWER

❀ ❀ ❀

❦ ADVANCED ❧

1

With the paper colored side up, fold it diagonally in both directions to obtain the creases shown.

2

Flip the paper over so that the colored side is down.

3

Fold one side of one corner to the middle, along the center line. Crease sharply.

4

Repeat for all four corners. This is how the paper should look after both sides of all four corners have been folded into the center and then unfolded.

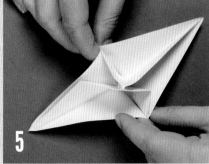

5

Squash the folds to flatten the paper.

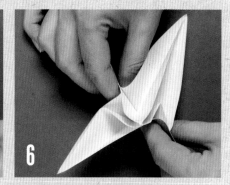

6

It should collapse easily with the exception of the center point. Simply move the center point to the side, and then push to flatten and fold it down.

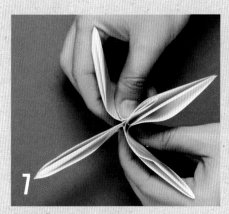

7

This is how the figure should look from the back.

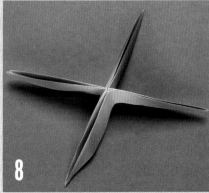

8

This is how the figure should look from the front.

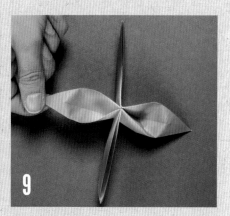

9

Use your thumb to open each petal and bend the tips back slightly.

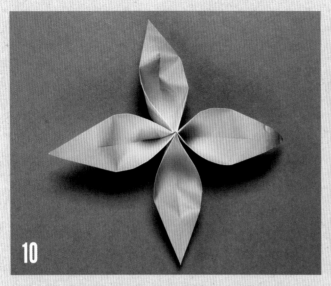

10

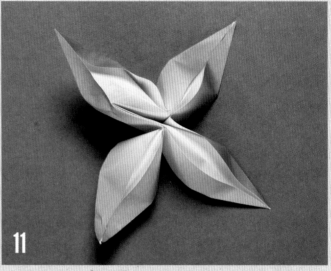

11

This is how the star flower should look from the front.

And this is how the star flower should look from the back.

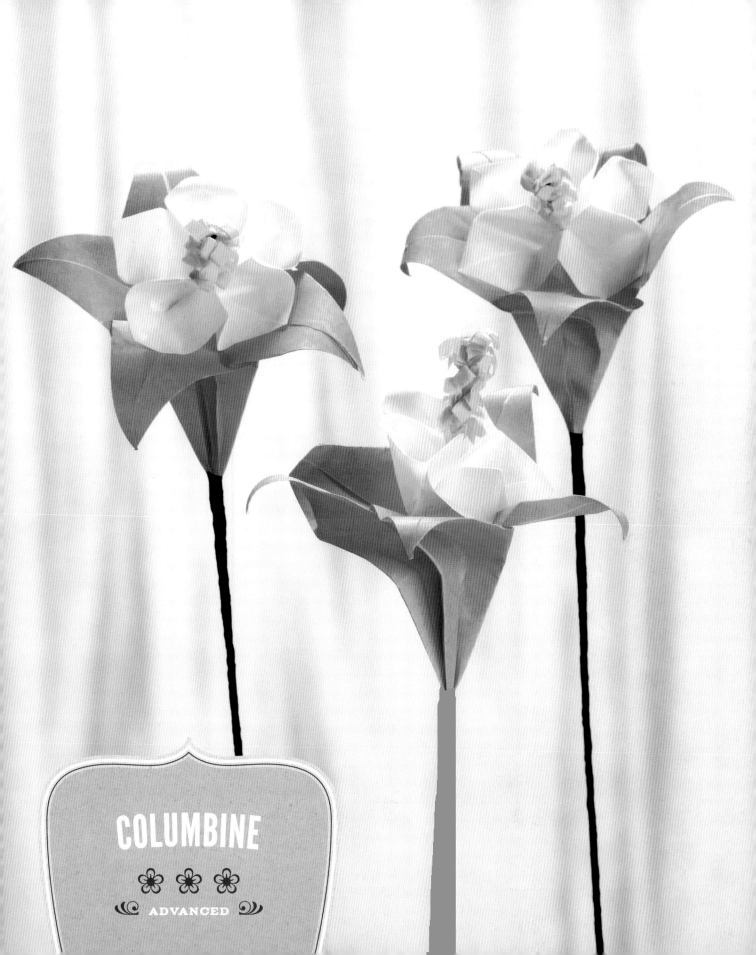

COLUMBINE

✿ ✿ ✿

〜 ADVANCED 〜

NOTE: FOR EACH COLUMBINE, YOU WILL NEED ONE 6-INCH-SQUARE (15.2 CM) SHEET OF PINK ORIGAMI PAPER, ONE 2-INCH-SQUARE (5.1 CM) SHEET OF WHITE ORIGAMI PAPER, AND A 4-INCH-LONG (10.2 CM) STRIP OF YELLOW TISSUE PAPER. YOU WILL ALSO NEED A FLORAL WIRE STEM WITH FLORAL TAPE WRAPPED AROUND ONE END OF IT, SCISSORS, AND GLUE.

1

Turn the two squares of paper into pentagons (page 24).

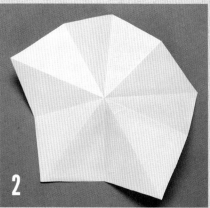

2

Start with the pink pentagon, colored side down, with one point at the top and a flat edge at the bottom. Notice that the pentagon is made up of five diamond shapes, each with a crease in the middle.

3

Valley fold the top left side of the pentagon from the diamond point at the top to the center of the middle crease of the diamond directly to the left.

4

Repeat on the right side of the pentagon. This is how the paper will look after both folds.

5

Turn the pentagon until the diamond to the left is now at the top of the pentagon. Repeat steps 3 and 4. Continue turning the pentagon and creasing until all five points have been creased on each side and the creases have formed a star pattern inside the pentagon.

6 Fold the shape into a diamond structure.

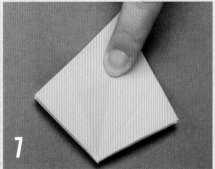

7 Make sure the open part of the diamond is at the bottom.

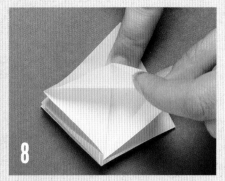

8 Now create a petal fold (page 15). Open the bottom of the figure by pulling up in the middle as shown in the photo.

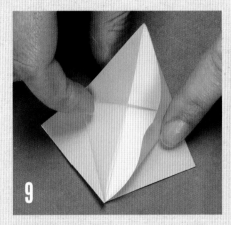

9 Then close the lateral flaps in.

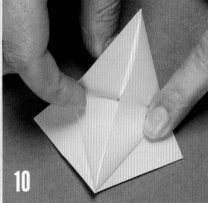

10 Close the flaps until they align in the middle.

11 This will create a triangle at the tip where the two sides meet. Fold the triangle down.

12 Repeat for all sides. Then place the figure on a flat surface with a smooth side facing up.

13 Diagonally fold the top left side to the center and crease well.

14 Fold the left side flap over to the right.

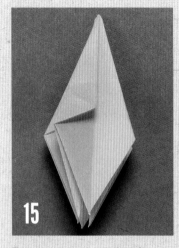

15

Repeat steps 14 and 15 for all sides.

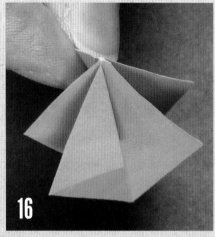

16

Hold the figure open side down on a flat surface.

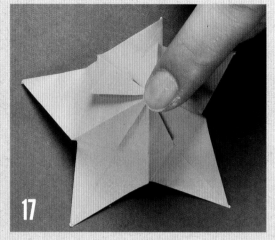

17

Push down gently as you arrange each flap so the flower opens in a clockwise direction.

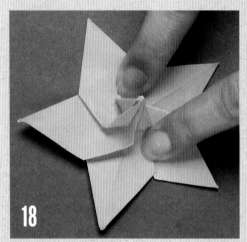

18

Flatten each petal as you are arranging it.

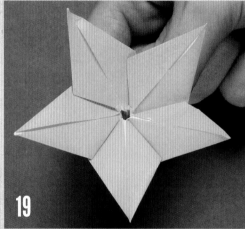

19

This is how the completed figure will look.

20

Use a bamboo stick to curl back the tip of each petal.

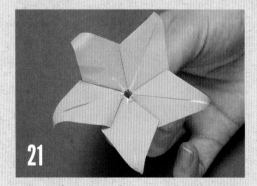

21

This is how the completed sepals will look.

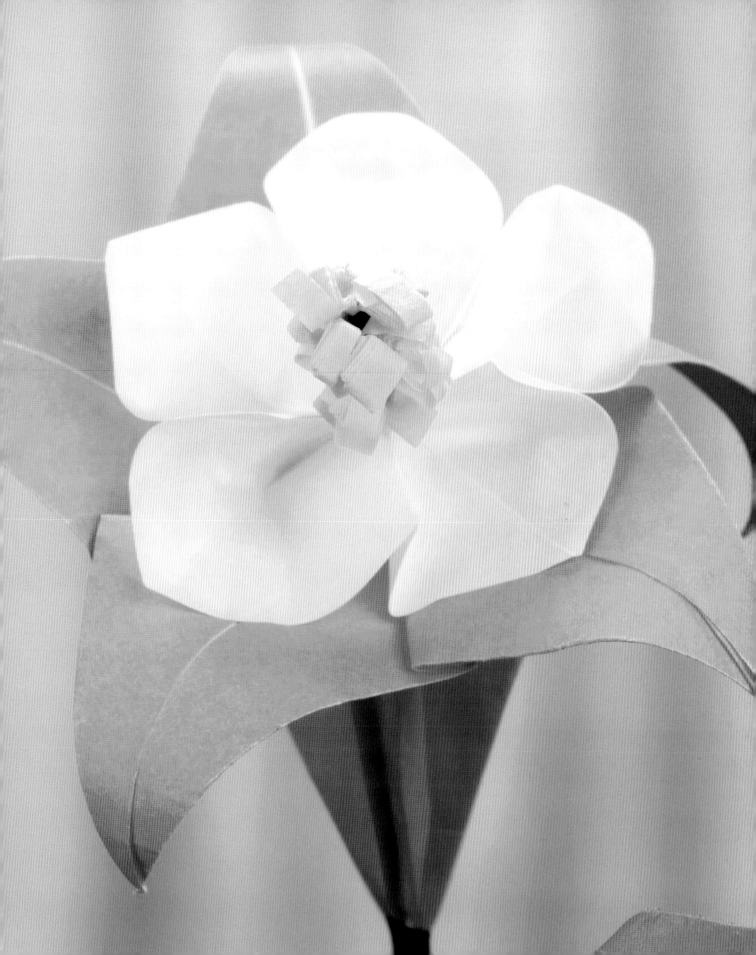

TO MAKE THE WHITE PETALS

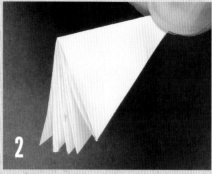

1 Collapse the small white pentagon into a triangle.

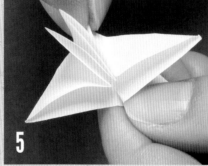

2 Fold the figure in half on its center crease.

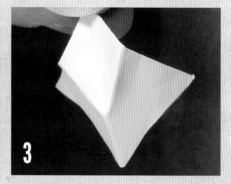

3 With the tip of the figure facing up, make an inside fold (page 14) in the tip.

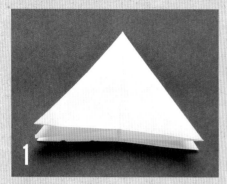

4 This is what the folded tip will look like from the side.

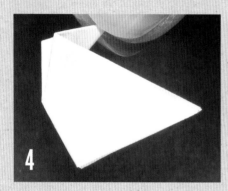

5 Holding the figure by the folded tip, open it up.

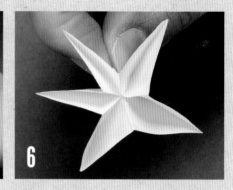

6 Insert your thumb into each petal to open it completely.

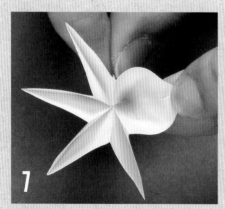

7 Finish by curling the tip of each petal back gently.

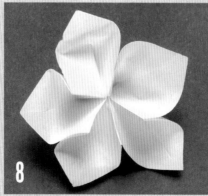

8 This is how the completed petals should look from the front.

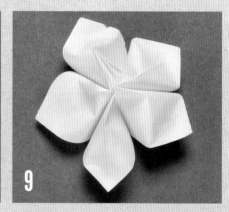

9 And this is how the completed petals should look from the back.

MAKING THE STAMEN

1

Valley fold the strip of yellow tissue paper in half horizontally.

2

Valley fold the top (folded) edge of the figure.

3

Make small cuts along the folded top edge. The cuts should go just slightly past the bottom edge of the fold.

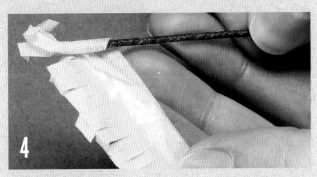

4

Turn the paper over. Apply glue to the bottom edge of the strip. Slowly wrap the yellow strip around the floral-tape-wrapped end of the wire stem.

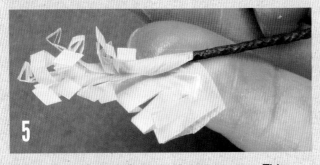

5

Slowly spiral the strip down the floral wire stem. This is how the completed stamen should look.

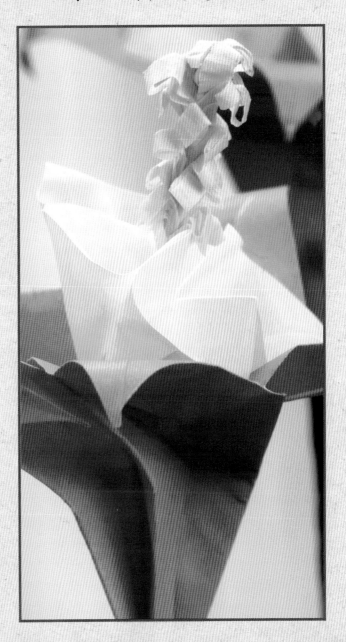

ASSEMBLING THE FLOWER

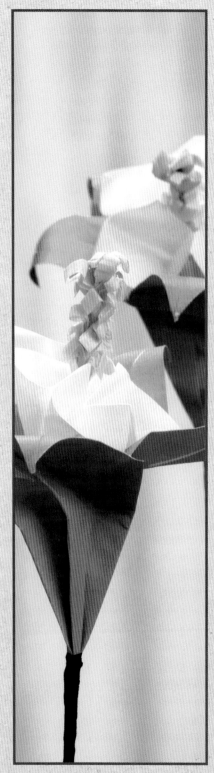

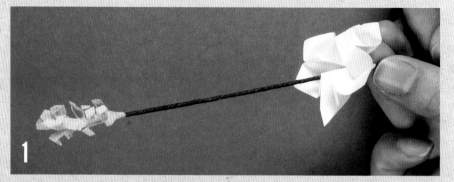

1 Insert the plain end of the floral wire stem through the middle of the small white petal section.

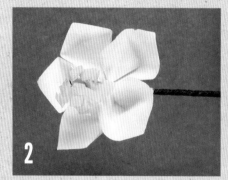

2 Carefully slide the white petal section all the way up to meet the stamen as shown.

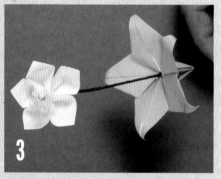

3 Now insert the plain end of the wire stem through the middle of the pink sepals section.

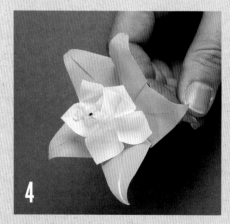

4 Push the pink sepals section all the way up to meet the white petal section as shown.

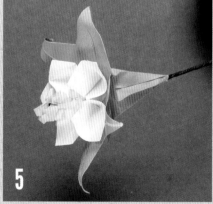

5 This is how the completed columbine should look.

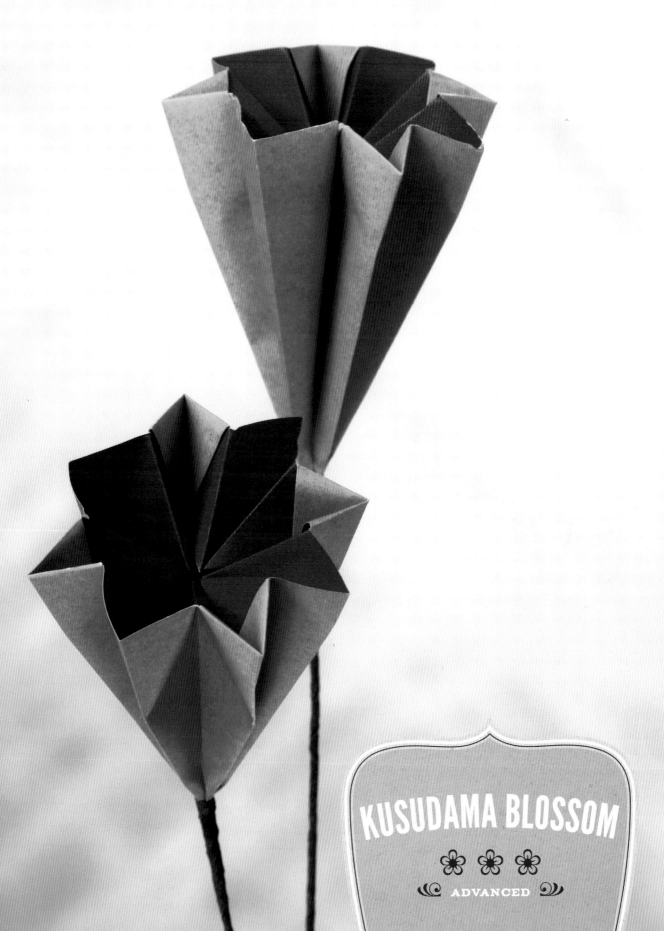

NOTE: USE ORIGAMI PAPER THAT IS A DIFFERENT COLOR ON EACH SIDE FOR THIS FLOWER.

1 Make a square base (page 16) with the color you want on the inside of your finished flower (red in the example shown) on the outside of the square base.

2 Diagonally fold the left triangular flap in to meet the center crease.

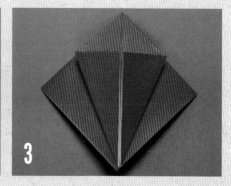

3 Repeat for the right side.

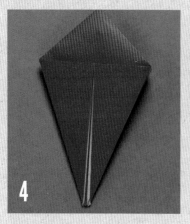

4 Turn the paper over and repeat steps 2 and 3 on the other side.

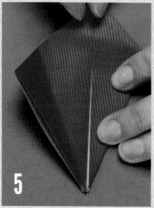

5 Open the flap on the left side.

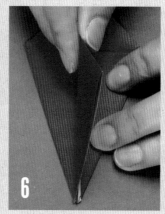

6 Lift the flap up.

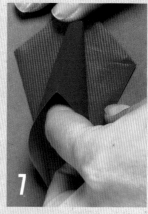

7 Open the flap by inserting a finger.

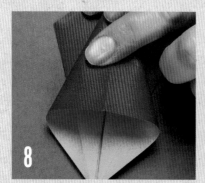

8 Then flatten the flap with a squash fold (page 14).

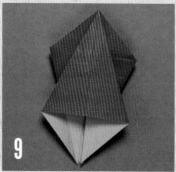

9 Make sure its center crease aligns with the center line of the figure.

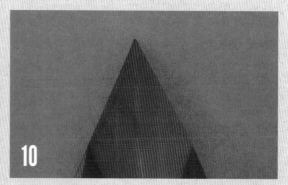

10 Repeat for the three remaining flaps. When you are done, the paper should be diamond shaped with a solid-colored side facing you and a solid-colored side on the back. There will be two pre-creases at the base of the diamond.

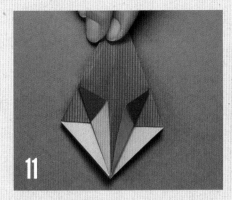

11

Use these pre-creases to fold each side into the center.

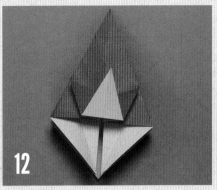

12

Fold the newly formed tip up as shown in the photo.

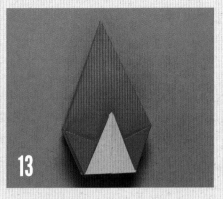

13

Repeat for all remaining sides.

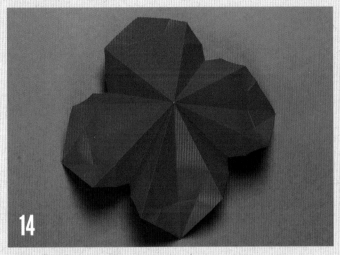

14

Make sure all of the creases are sharp, and then unfold the entire figure. The color you want on the inside of the finished flower should be facing up.

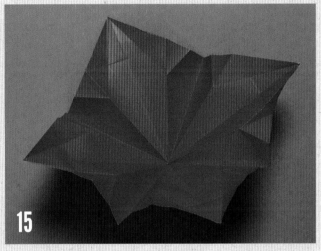

15

Push the center of the paper in so it is concave instead of convex.

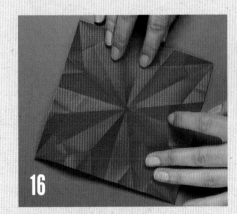

16

Isolate one of the four diamond shapes in one of the four squares of the paper. Locate the creases to the left and to the right of the diamond shape (these are the interior lines that delineate the square surrounding the diamond).

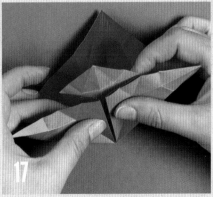

17

Mountain fold these two side creases in behind the diamond shape until they meet at the back center crease of the diamond. (The photo shows this from the back side of the figure.)

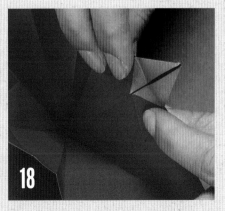

18

Fold the left and right sides of the tip in to align with the center crease.

19

Fold the newly formed, thinner tip into the center.

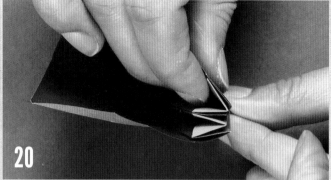

20

Valley fold the section you just worked (the diamond with the tip folded down) in on itself.

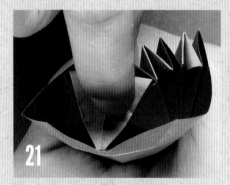

21

Repeat steps 16 through 21 for the other three diamond shapes.

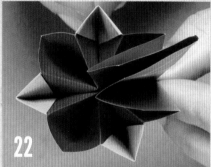

22

This is how the paper should look when you are down to the last diamond shape.

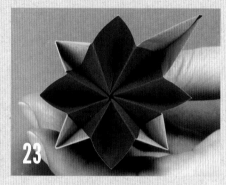

23

Here is the flower before the last tip is folded in.

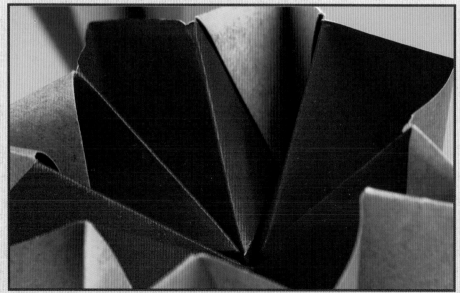

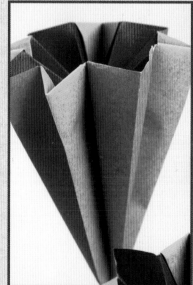

ABOUT THE AUTHOR

Anca Oprea began learning origami in her hometown of Satu Mare, Romania. When she moved to Minnesota five years ago, her access to origami paper greatly increased and her interest in the craft blossomed. Currently studying to become an ESL teacher, Anca uses origami as an educational tool, especially for math classes. She lives with her husband in the suburbs of Minneapolis-Saint Paul, Minnesota.

INDEX